ART U NEED

MY PART IN THE PUBLIC ART REVOLUTION

BOB AND ROBERTA SMITH

black dog
publishing

\\\\\\CONTENTS\\\

Art U Need is the most recent of a series of projects by visual arts development agency Commissions East which aims to encourage debate about the role and impact of artists working in the public realm. In its projects, Commissions East continues to address how artists can work in ways that are appropriate to the social and physical context of a place, genuinely transforming peoples' feelings about the places that shape their everyday life.

The project was jointly funded by the East of England Development Agency's (EEDA) Investing in Communities Programme and the Art Council England, East (ACEE) with the objective of bringing together local communities and artists to work together on an idea or set of proposals of benefit to the locality. The project provided opportunities for communities to work together, to uncover their own stories and to learn about and appreciate others'.

South Essex, the site for *Art U Need*, is well known for its rich history and strong communities, and as part of The Thames Gateway regeneration and the resulting new communities, provided a unique challenge for artists to become involved in a meaningful way in a rapidly changing area. People in South Essex are often very proud of their local area—whether it is the long history, the rural environment, heritage or strong family connections. There is great strength in many communities and a keen desire to be much more actively involved in the changes around them.

Art U Need followed a series of projects initiated by Commissions East in South Essex over a number of years, learning from these projects and building on their successes. Nina Pope and Karen Guthrie's project *Bata-ville*, about the idealistic community established by the Bata shoe company on the banks of the Thames at East Tilbury, resulted in a film of a coach trip made by local residents to the origins of the company at Zlin in the Czech Republic, questioning assumptions about the role of artists and regeneration. At the London Cruise Terminal, Stefan Gec's *Tilbury Mappamundi* investigated the area's important history of trade and immigration through a large scale projection in the largely disused station at the terminal, whilst Juneau Projects worked closely with the local community at Purfleet on a project at Aveley Marshes, an area recently reclaimed for public usage by The Royal Society for the Protection of Birds.

These projects, which revealed the wealth of history in this soon to be regenerated area and the strength of the existing communities, became the basis for *Art U Need*. The original objectives for the project, set by Thames Gateway South Essex Partnership (TGSEP), were to "rejuvenate five neglected spaces", "involve local communities in the process" and "produce work of long term merit and quality". These objectives became the focus of preliminary discussions about what was possible, the appropriateness of this, and how local people might become involved.

The appointment of a lead artist by a steering group, comprising representatives from TGSEP, ACEE and the participating local authorities, to oversee the programme, act as curator and support the commissioned artists was an important element of the scheme. Bob and Roberta Smith has extensive experience of working publicly and is renowned for his challenging approach. His statement "I am not a public artist—but I work with the public" set the tone for the project, reflecting the spirit of these preliminary discussions, and the steering group's intention that this should not be just another public art project with an attached community programme. His encouragement to look again at the five sites that had originally been suggested by participating partners was well founded, ultimately resulting in projects in places that had resonances for the people who lived there. Although uneasy with the title of lead artist, his guiding of the process through gentle cajoling, persuasion and encouragement contributed to the confidence of the five consultation groups that had been set up to oversee the projects at the five sites, resulting in projects that were much more ambitious than originally anticipated.

The selection of the site artists by local groups resulted in the appointment of Lucy Harrison, Andrea Mason, Milika Muritu, Hayley Newman and Jane Wilbraham. Although all five had relatively limited experience of public art projects, the consultation groups were convinced that they could meet the aims of the project whilst challenging assumptions about public art. Although the project was often described as a "public art revolution", in many ways it was a subtle campaign in which the commissioned artists managed to find ways of working that successfully engaged people on a multitude of levels. It is commonplace now for there to be high expectations for artists working in the public realm and as expected there were challenging points in the development of the projects and Bob and Roberta's generosity with his time at these points was an important factor in resolving some of the issues.

Projects like *Art U Need* depend on the support of a broad range of individuals and organisations. The funding and support from ACEE and EEDA, provided firm foundations for the project, with day to day management from TGSEP through their project manager Catherine Sackey. All three of these organisations gave unwavering support throughout the project. In addition, many individuals contributed to *Art U Need*, by sitting on local groups, hosting events and, above all, participating in the projects.

This book tells the *Art U Need* story. Written by Bob and Roberta Smith as a personal diary, which reflects his own experiences of working in communities and raises questions about the role of artists in regeneration, stressing the importance of involving the public in a meaningful way.

We hope that the success of *Art U Need* will herald new models of working to ensure better community engagement, encouraging the use of art as a way of signalling change for better cultural provision. It is hoped that the project becomes an exemplar that will demonstrate to planners, developers, local authorities and policy makers how culture should be an integral part of regeneration.

It is too early to define the legacy of the project. It has brought together existing and new residents, and enabled people to look anew at open spaces. Above all, it has started a conversation, questioning expectations about art and regeneration, and as Bob and Roberta Smith suggested has provided "an antidote to large scale iconic art".

\\\\\\\\\DAVID WRIGHT, COMMISSIONS EAST, JULY 2007\\\

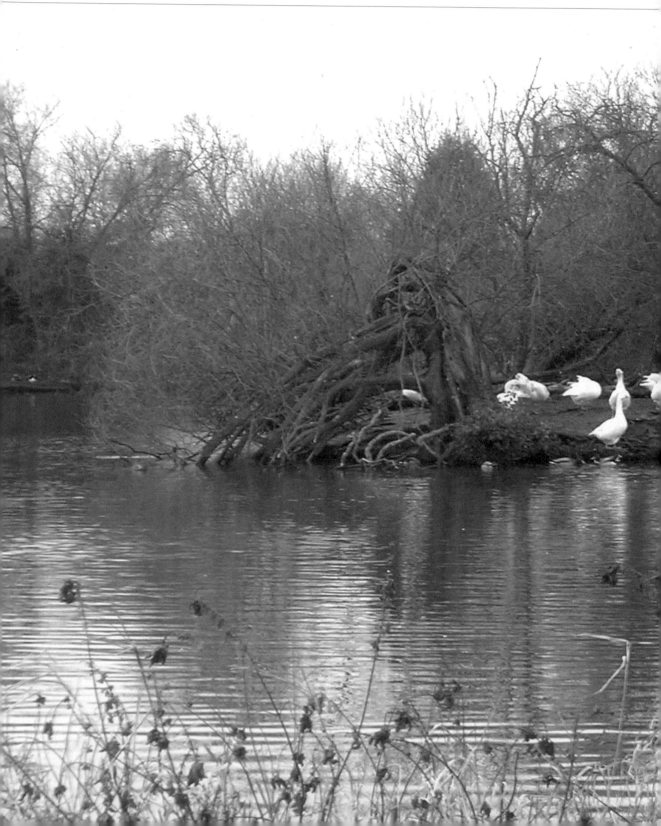

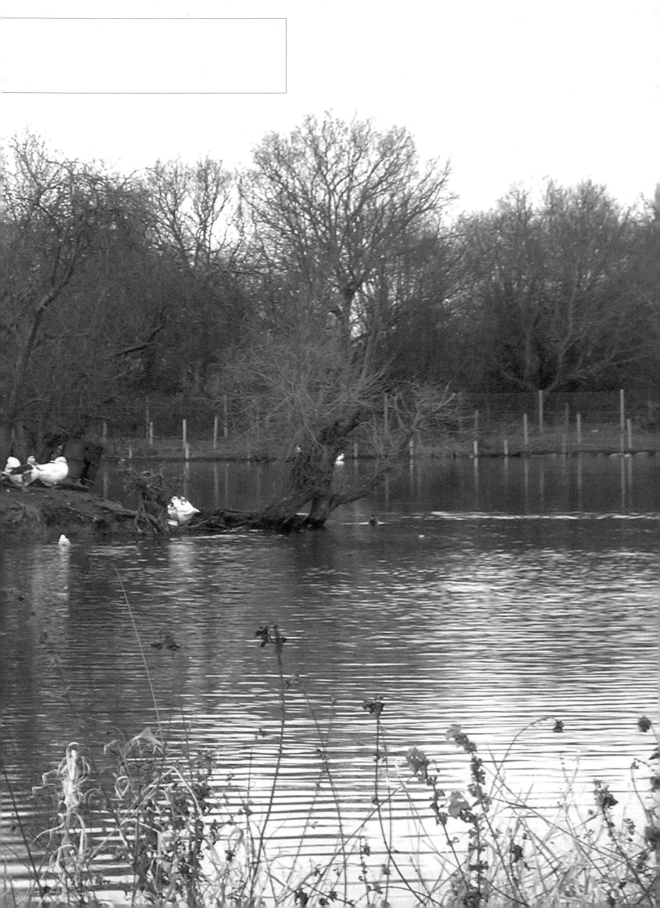

WHEN I WAS 10 I WANTED TO BE AN ARTIST. WHEN I WAS 20 I SAID I WOULD GIVE IT TEN MORE YEARS.

WHEN I WAS 30 I WAS FIRMLEY ESTABLISHED ON THE FAR FLUNG MARGINS OF AN ALTERNATIVE CULTURE. I EVEN LIVED IN NEW YORK

NOW I AM FORTY I HAVE NO MONEY, NO PENSION AND TWO KIDS.

GOD KNOWS WHAT LIFE WILL BE LIKE WHEN IM FIFTY?

Bob + Roberta Smith

SATURDAY 24 DECEMBER 2005

I phone my sister who works in a mental hospital to ask her
what she is doing at Christmas. She says although she has
booked the day off she is going in to work anyway because
Christmas isn't a happy time for everyone. I say "Christmas
isn't a happy time for anyone!"

MONDAY 27 FEBRUARY 2006

Paul Hedge, who runs the Hales Gallery, where I sell my
pictures, phones. He says he has sold a painting about being a
failure for rather a lot of money. The painting was a sign that read:

WHEN I WAS TEN I WANTED TO BE AN ARTIST.
WHEN I WAS 20 I SAID I WOULD GIVE IT TEN MORE YEARS,
WHEN I WAS 30 I WAS FIRMLEY ESTABLISHED ON THE
FAR FLUNG MARGINS OF AN ALTERNATIVE CULTURE.
I EVEN LIVED IN NEW YORK
NOW I AM FORTY I HAVE NO MONEY, NO PENSION
AND TWO KIDS.
GOD KNOWS WHAT LIFE WILL BE LIKE WHEN I AM FIFTY?

The painting about failure has sold, which is a success, but in
its own way is also a failure. I reflect on the probable fact I may
not sell another painting for three or four months, and Hales
Gallery will take 50 per cent of the sale price. Suddenly life
seems precarious and the financial situation of our young
family distinctly dodgy.

*When I Was 10 I Wanted To Be
An Artist.*
Signwriter's enamel on wooden
doors. Bob and Roberta Smith,
2006. Courtesy Hales Gallery,
copyright the artist.

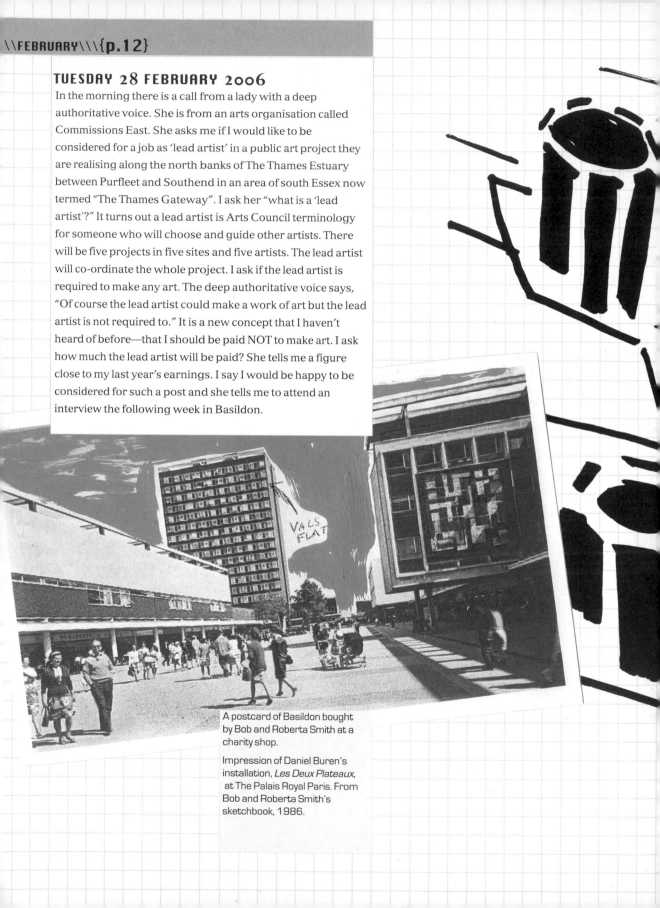

TUESDAY 28 FEBRUARY 2006

In the morning there is a call from a lady with a deep authoritative voice. She is from an arts organisation called Commissions East. She asks me if I would like to be considered for a job as 'lead artist' in a public art project they are realising along the north banks of The Thames Estuary between Purfleet and Southend in an area of south Essex now termed "The Thames Gateway". I ask her "what is a 'lead artist'?" It turns out a lead artist is Arts Council terminology for someone who will choose and guide other artists. There will be five projects in five sites and five artists. The lead artist will co-ordinate the whole project. I ask if the lead artist is required to make any art. The deep authoritative voice says, "Of course the lead artist could make a work of art but the lead artist is not required to." It is a new concept that I haven't heard of before—that I should be paid NOT to make art. I ask how much the lead artist will be paid? She tells me a figure close to my last year's earnings. I say I would be happy to be considered for such a post and she tells me to attend an interview the following week in Basildon.

A postcard of Basildon bought by Bob and Roberta Smith at a charity shop.

Impression of Daniel Buren's installation, *Les Deux Plateaux*, at The Palais Royal Paris. From Bob and Roberta Smith's sketchbook, 1986.

MONDAY 6 MARCH 2006

I have never been to Basildon before. The central square is reminiscent of Alexanderplatz but without the TV tower with the revolving restaurant where they serve beige food. Helping create the ambiance is a force nine gale. I shelter in Marks and Spencer. I love public sculpture. I enjoy Henry Moore's bronze lumps but I am aware that public art has moved on.

When I was a student we visited Daniel Buren's installation at The Palais Royal in Paris. Tall black and white bollards projected to and from various heights. The effect was sublime… but then The Palais Royal is in Paris, not Basildon. I also realise that although the budget is large we will not be building an 'Angel of the East'. Even if it was desirable to construct a monumental iron sculpture dominating the landscape, what we would be involved with would have to be much more modest and carefully thought out.

I make my way to the council offices. One Mrs Cravat at reception says: "You've come for the public sculpture." A very snappily dressed woman embodies the deep, authoritative voice I had heard on the phone. This is Joanna Baxendale. She introduces me to the interview panel, which includes a jolly chap with enormous sideburns named David Wright who set up and runs Commissions East. I start by telling them I am not a 'Public Artist', but I work with the public. I show them my recent projects which include *The Mobile Reality Creator* where I asked women to dress as men and discuss the big issues of the day, the *Art Amnesty* where I asked artists to pack in 'pretending' to be artists and get a proper job and *Improve the Cat* at Guido Carbone Gallery in Turin where I took busts of headless cats and asked the public to make improved cat heads.

Boos Paris SKETCH Book 1986.

TUESDAY 7 MARCH 2006

Joanna Baxendale phones to offer me the job. I say "Yes".

I phone my sister to tell her my news. She tells me I will build a huge folly to my already enlarged ego. I tell her it is not like that. She says: "Well, then you will end up labelling the poor by painting the buildings they live in in bright colours." She says you can tell 'run down' areas from the train because they have all been 'done up'. Cheery public art litters the open spaces. It's impossible to find a verge to park your car on, let alone take the engine out. You don't hear about large public art projects going up in Hampstead. I tell her she is bitter and twisted.

WEDNESDAY 8 MARCH 2006

The Delta Blues

I meet Joanna Baxendale and we travel from Fenchurch by train to Purfleet Station. The train is remarkably fast and smart. At first glance the whole train appears to be first class. The gleaming C2C train takes us through 1960s estates, which were built in the aftermath of the destruction of the East End by the Luftwaffe. Further out we pass by the huge decaying Ford metropolis at Dagenham then across a beautiful broad marsh and arrive smartly at Purfleet. Purfleet Station itself is typically English. There is something charming about the fact that we have to wait for our train to leave the station before the level crossing gates are opened and we can continue our journey on foot towards the Thames. As we walk towards a possible proposed site for an artwork at the Garrison Estate, Jo tells me more about the project and the day ahead.

I have been appointed to oversee the project. The first task will be to identify five sites that we think are interesting for placing artworks. The second task will be to invent and engage in a democratic process of appointing five artists who will work with each site. At each location, a steering group has been formed of local people to 'help' Commissions East choose the artist. In the pit of my stomach an enzyme is released causing what is known as the 'sinking feeling'. I wonder if this is going to be art by committee and I have just been appointed as the Chair.

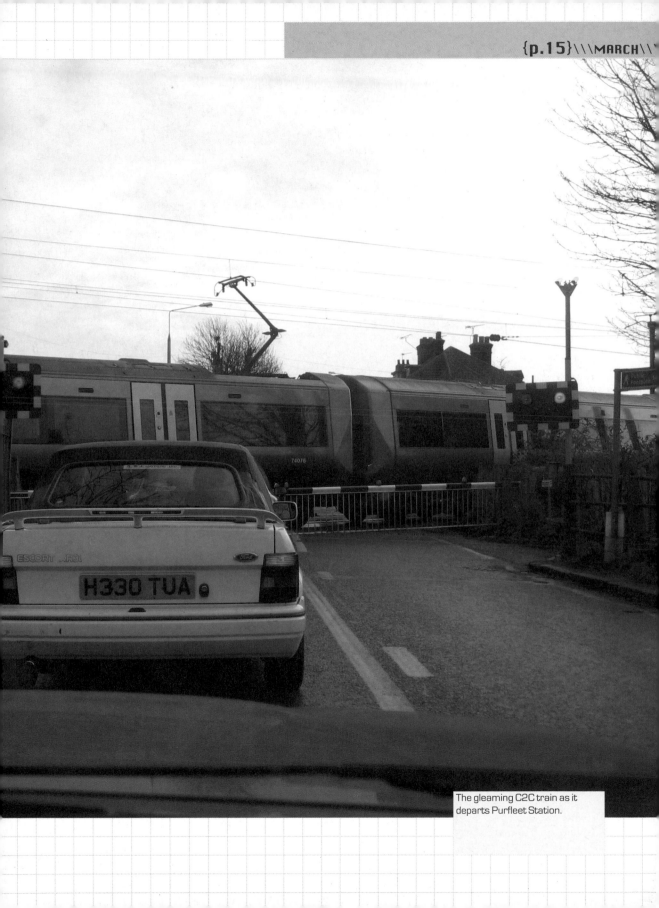

The gleaming C2C train as it departs Purfleet Station.

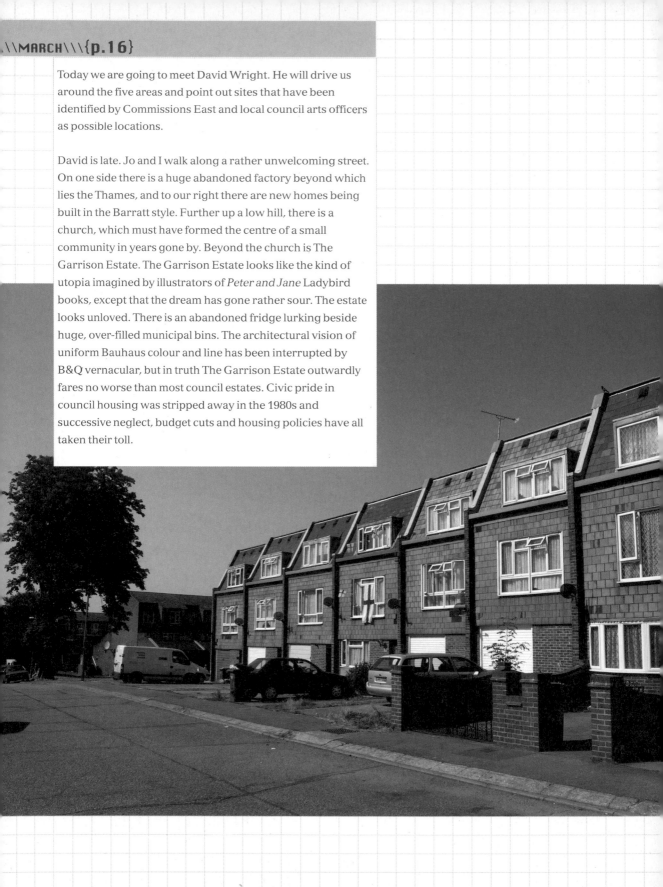

Today we are going to meet David Wright. He will drive us around the five areas and point out sites that have been identified by Commissions East and local council arts officers as possible locations.

David is late. Jo and I walk along a rather unwelcoming street. On one side there is a huge abandoned factory beyond which lies the Thames, and to our right there are new homes being built in the Barratt style. Further up a low hill, there is a church, which must have formed the centre of a small community in years gone by. Beyond the church is The Garrison Estate. The Garrison Estate looks like the kind of utopia imagined by illustrators of *Peter and Jane* Ladybird books, except that the dream has gone rather sour. The estate looks unloved. There is an abandoned fridge lurking beside huge, over-filled municipal bins. The architectural vision of uniform Bauhaus colour and line has been interrupted by B&Q vernacular, but in truth The Garrison Estate outwardly fares no worse than most council estates. Civic pride in council housing was stripped away in the 1980s and successive neglect, budget cuts and housing policies have all taken their toll.

Jo shows me around. I question if putting a sculpture here will do anyone any good. My own philistinism begins to percolate to the surface. What would be the point of a public art project here, and who would it benefit?

The south side of the estate fronts The Thames Estuary. There is a long path that separates the estate from the river. The view is astounding—a mudflat extends as far as the eye can see in both directions. To the east of the estate is the marsh we zipped across in the natty C2C train. Jo tells me it is a bird sanctuary. There are plans to build a visitor centre. I try to imagine what it would be like to live here. The estate is very close to London and located in an extraordinary area of natural beauty, but because it appears rather neglected and its services are rather poor, you could be forgiven for thinking that the residents might feel that the party had moved on.

David Wright arrives. He tells me a complicated story, the first of many that I will forget and get wrong that outlines the history of the local politics of the site. I don't take it all in. He shows me an area between two huge banks of housing where it has been suggested we locate something. I wonder what I have got myself into. I begin to see how and why public art is seen as a worthy cul-de-sac that so many artists' careers have run into.

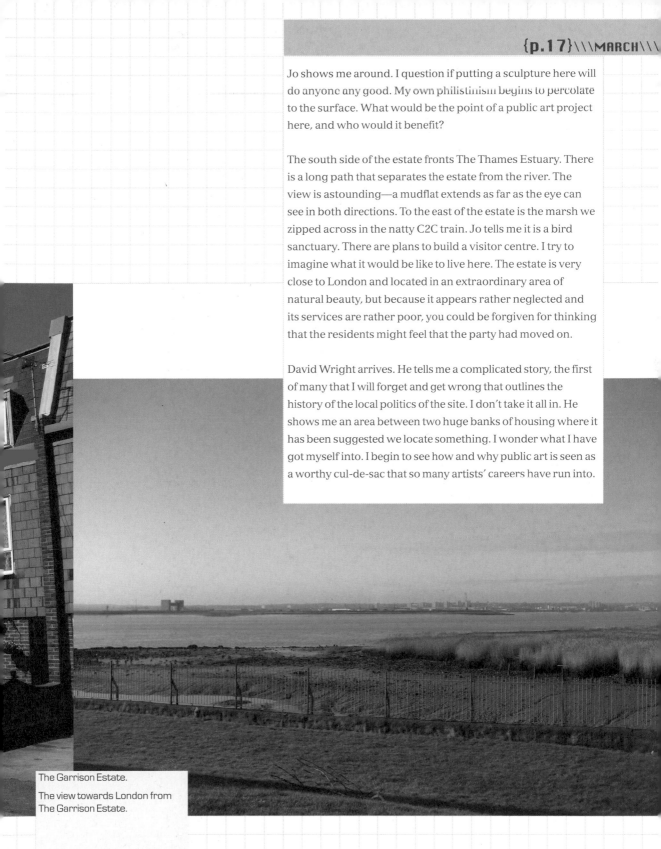

The Garrison Estate.

The view towards London from The Garrison Estate.

I have a vision. It is a dark vision. It is the sort of vision that an art Scrooge might have.

There is a man in his mid-40s. He is known in the 'art world' for making art with some political and intellectual credibility, but he does not make work he can really sell. Decades of studying Duchamp and other conceptual artists have shown him the art market is a cesspit of corruption. The only way to fund his projects is to apply to the Arts Council for money. At first this made him feel like a 'doley' but because they never gave him any money it also seemed a dream. After some time, the Arts Council took him seriously and paid for him to make work, but now he is in his 40s the funding seems a memory. Newcomers have taken his place. He is offered a sum of money to make a public artwork. Great. A really decent sum of money realises his vision but with it comes a series of criteria that he would rather not confront. Every detail must have a reason and nothing is left to poetic serendipity. Now he finds himself wondering what he can put in between two huge banks of housing estate on the windswept shores of the river in the newly termed area of The Thames Gateway.

The back entrances of some of the buildings on The Garrison Estate.

The Garrison Estate community centre.

Oh good Lord, that man is me! Good will to all men.
Bah humbug!

As we walk to David Wright's car, we pass by the reason
the estate is called the "Garrison". There are two gigantic
Georgian buildings, which once housed the British Army in
Wellington's time. The buildings are preserved beautifully.
In one, I am told, is housed a collection of artefacts which
document local and military history. The other building is
a community centre.

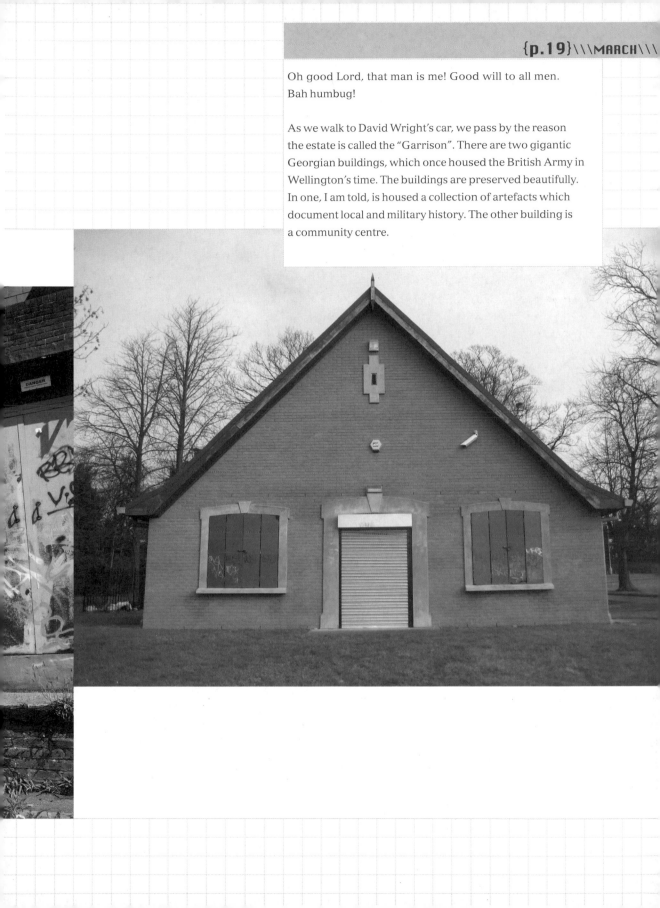

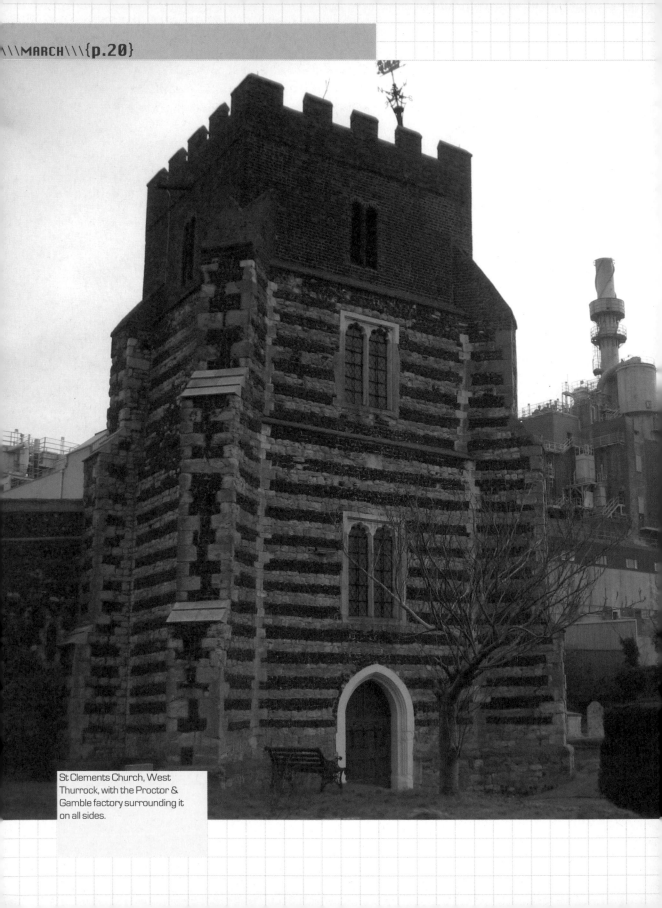

St Clements Church, West Thurrock, with the Proctor & Gamble factory surrounding it on all sides.

David and Jo ask what are my impressions. I affect a positive mumble but I am aware I have headed out across The Thames Estuary mudflat of public art only to loose my boots at the first step, leaving self-doubt to ooze between my toes.

David is excited about the day ahead. First he wants to show me a remarkable church in the shadow of the Dartford Bridge, and then on to Canvey Island via a Modernist housing estate in East Tilbury. Lunch in Canvey Island is to be followed by a meeting with some residents at Northlands Park Council Estate in Basildon, then on to Southend and finally we will visit a very promising pond in Rochford. Both David and Jo seem so genuine in their enthusiasm for their itinerary it rubs off on me….

We all pile into David's car and he takes us under the Dartford Bridge on a journey along a labyrinth of C and D roads until we come across an extraordinary sight. In front of us is the largest building I have ever seen. It has pipes and ducts sprouting from all sides and looks like a children's fantasy of a factory. In front of the building but surrounded on three sides is a beautiful Norman church. It is dwarfed by the factory but stands proud of it in its graveyard. David tells us the church was used in the film *Four Weddings and a Funeral*. In the film they Mac'd out the factory and replaced it with blue sky. The factory produces soap and the air smells of artificial lemon, like a cheap air freshener—not fresh at all.

This is the first stop on David Wright's tour of the hidden architectural and historical delights of The Thames Gateway.

Our next stop is the Bata Estate. It has begun to drizzle and the sky is leaden.

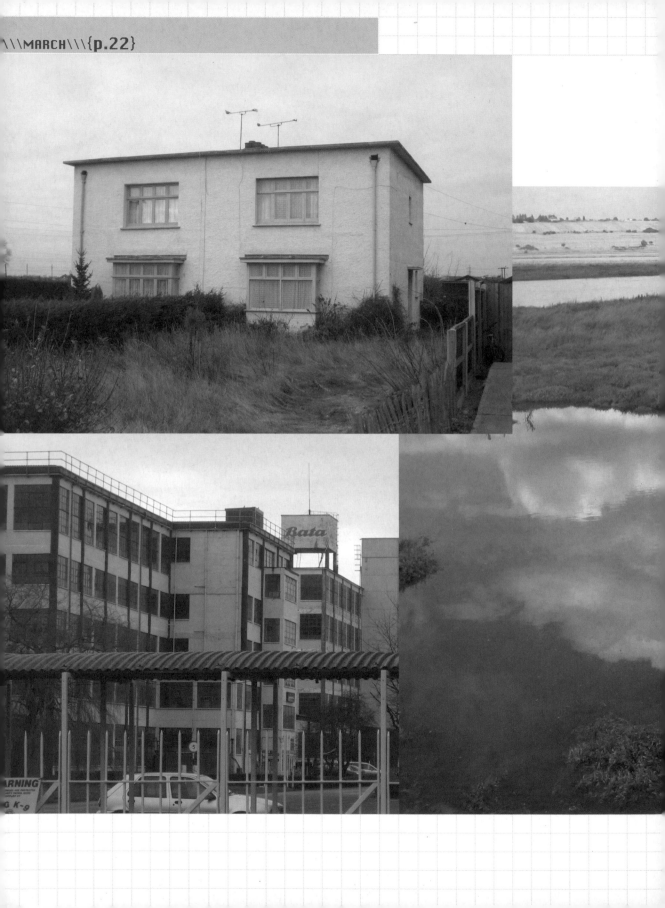

The Estate is a little gem of Middle European Modernism transported right to where no one would see or appreciate it: East Tilbury. The Czechoslovakian shoe company, Bata, produced strange, bland, unfashionable, functional footwear from this extraordinary Bauhaus factory and living quarter. Elsewhere, the Rowntree chocolate factory in York had a go at this sort of total social engineering where workers live like Modernist ants. Everything was provided—work, rest and play (in that order probably), but it didn't work out. Now the factory is a self storage unit, and the houses ruined by the occupants' addiction to Homebase. Like everything else, the shoes are now made in China. The Bata Estate is impressive, but the loony utopian dream is dead.

David thrusts a DVD by two artists named Karen Guthrie and Nina Pope into my hand. The DVD is called *Bata-ville* and documents a project Commissions East initiated with former workers of the Bata factory.

Jo says before we break for lunch, we must visit the sites in Canvey Island where we might do a project. The first site is beside an out-of-town superstore car park. We park, and then head out across the flat lands along a footpath and across a creek. In the distance I can here a curlew cry. Two large pipes come from nowhere and go nowhere supported in a substantial iron gantry. The whole sorry assembly is a rusted red. Running up to the base of the pipes is a two-lane highway complete with roundabout and streetlights. Nature has overtaken the road and weeds have broken up the tarmac. Each street lamp leans a different way. David tells us the story. An oil company bought the site with a view to creating an oil terminal and refinery. The pipes were for bringing the oil on shore from the tankers. They dredged the Thames in order to make it deep enough for the tankers and built the road for lorries to take the oil away, but they made the mistake of putting the highly fertile dredged mud on the land. Before long a rare orchid popped its head out of the mud. Along came some environmentalists and the area has now been declared a site of special scientific interest. No oil terminal but also no art. It is going to be difficult to do anything here because of all the environmental restrictions. It's a beautiful place and the story seems like a modern day fable.

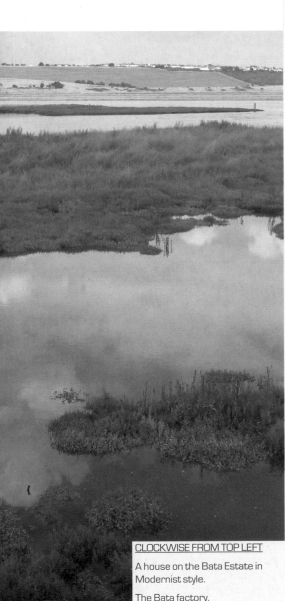

CLOCKWISE FROM TOP LEFT

A house on the Bata Estate in Modernist style.

The Bata factory.

The marshes on the north side of Canvey Island, where the ashes of punk legend Lee Brilleaux were scattered.

The second location in Canvey Island is called Canvey Heights. It's a former landfill site that has been landscaped. From the top of Canvey Heights you can see Southend with its burnt out pier to the east and looking west one can just make out Canary Wharf. It is incredibly windy but immediately I can see the possibilities and indeed the point of attracting people to this really beautiful vantage point. By this time we are all hungry and we go in search of lunch. There is a delightful 1930s rotunda restaurant built into the sea wall just along the beach. It looks inviting but upon reaching it we find it is closed. Instead we feast on pub grub in one of Canvey Island's many serviceable hostelries in town.

There is a third possible site on Canvey Island that David and Jo have visited but we are all convinced that Canvey Heights is so strong that we press on to Basildon and the Northlands Park Neighbourhood.

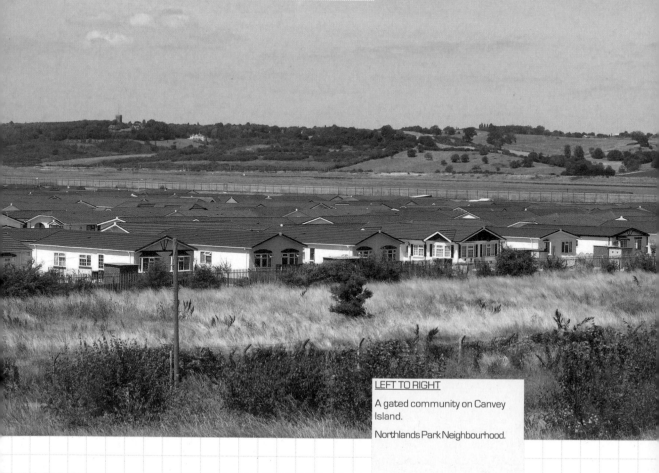

LEFT TO RIGHT

A gated community on Canvey Island.

Northlands Park Neighbourhood.

The Northlands Park Neighbourhood is a low-level 1970s council development. It has attractive pathways between blocks of housing and shops. A meeting has been arranged with some of the residents. We are shown into a community centre where seven people stand up to greet us. David and I try to explain that we want to do an art project at Northlands Park. The residents are concerned that whatever we do will get vandalised. It seems the attractive pathways we strolled along in daylight are rather forbidding at night and vulnerable to teenagers armed with spray cans. We hear about the problems with the estate but what I find exciting is that here is a group of people interested enough to turn up to listen to our highly speculative ideas about art. I leave the meeting excited. Art is about people after all—I can see that whatever we do here is really needed and that if we get this project right, it will have a real benefit.

Heartened by the residents of Northlands Park Neighbourhood, we make our way to our last stop, a pond adjacent to Rochford station. Rochford seems different to the other locations in that it is a rather comfortable village on the northern fringes of Southend. The pond was once the source of water for the steam trains that took commuters and day-trippers in and out of London, and around it runs a narrow gauge model railway track.

The pond is used by anglers. It sits in a park. David tells us that the council have proposed this park for our project, because the area is underused. There are 'pockets' of deprivation here. As we walk around the pond and I ponder what David and Jo have in mind as the next step in our project.

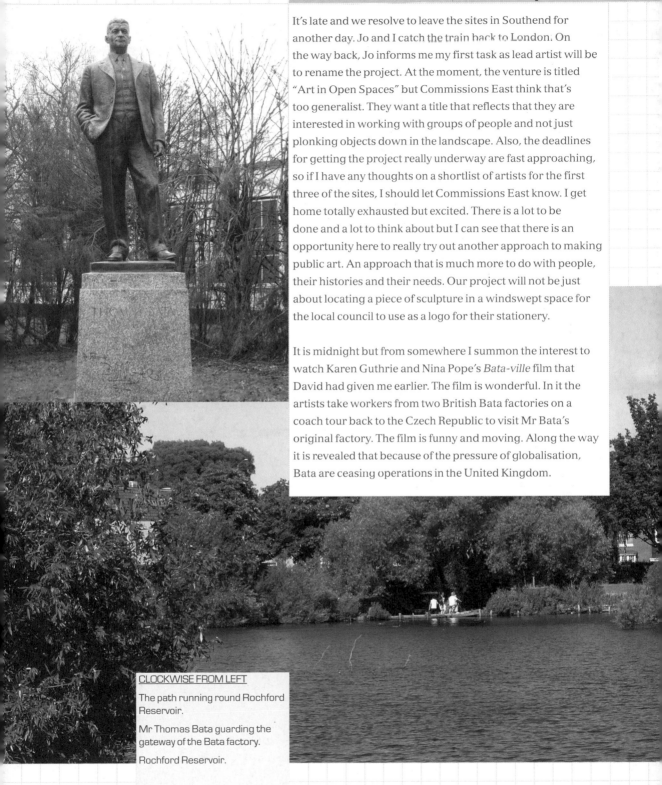

It's late and we resolve to leave the sites in Southend for another day. Jo and I catch the train back to London. On the way back, Jo informs me my first task as lead artist will be to rename the project. At the moment, the venture is titled "Art in Open Spaces" but Commissions East think that's too generalist. They want a title that reflects that they are interested in working with groups of people and not just plonking objects down in the landscape. Also, the deadlines for getting the project really underway are fast approaching, so if I have any thoughts on a shortlist of artists for the first three of the sites, I should let Commissions East know. I get home totally exhausted but excited. There is a lot to be done and a lot to think about but I can see that there is an opportunity here to really try out another approach to making public art. An approach that is much more to do with people, their histories and their needs. Our project will not be just about locating a piece of sculpture in a windswept space for the local council to use as a logo for their stationery.

It is midnight but from somewhere I summon the interest to watch Karen Guthrie and Nina Pope's *Bata-ville* film that David had given me earlier. The film is wonderful. In it the artists take workers from two British Bata factories on a coach tour back to the Czech Republic to visit Mr Bata's original factory. The film is funny and moving. Along the way it is revealed that because of the pressure of globalisation, Bata are ceasing operations in the United Kingdom.

CLOCKWISE FROM LEFT

The path running round Rochford Reservoir.

Mr Thomas Bata guarding the gateway of the Bata factory.

Rochford Reservoir.

SUBMAR

ART IN THE FLOOD

A drawing from Bob and Roberta
Smith's sketchbook, March
2006.

THURSDAY 9 MARCH 2006

A VERY DIFFERENT KIND OF PUBLIC ART.

I go to do an art project in a dementia day centre in Dagenham for The Serpentine Gallery. After the project one of the ladies says, "Are we still here?" I say, "Yes. We are still here."

FRIDAY 10 MARCH 2006

Late at night I scribble some alternatives to the "Art in Open Places" project title.

IN YOUR GATEWAY
Art in The Thames Gateway

OVER THE THRESHOLD
Art in The Gateway

OBSTICLE
Stuck in The Gateway

SWEETENER
Art and Regeneration

I SAW AN EYE SORE
Art in The Gateway

WEALTH ON PARADE
Art in 5 Areas of Deprivation

THE LONELY VOLUME
Art in Windswept Spaces

NOTHING LEFT FOR FANTASY
Art on the North Bank of the Thames

ROMANCE OF THE HUMDRUM
Local Artists/Site Specific Art and Mud

THE PLEASURE OF FEEDING AND BEING FED
Exciting Commissions of New Art in the Thames Gateway

OVER THERE
New Art in Thurrock

ART WHERE SKY AND WATER MEET

SUBMARINE
Art in the Flood Plane

ART U NEED

My favourite is "Submarine: Art in the Flood Plane". I imagine life boats attached to all the lamp posts being made mandatory in low lying areas.

THURSDAY 16 MARCH 2006

Second session at the dementia centre. Only the old lady who asked if we were still here, remembers to come.

TUESDAY 21 MARCH 2006

Meet Sally O'Reilly and Mel Brimfield at a day centre in
Chadwell Heath. Sally and Mel are part of a project that
my wife, artist Jessica Voorsanger, and I are doing at The
Serpentine called *Hearing Voices Seeing Things*, in which we
have invited artists to work with mental health care users.
Today Sally and Mel ask a group of schizophrenics and manic
depressives to make the sounds they hear when they get up in
the morning including going to the bathroom. I am not sure,
but I wonder if all the sounds are generated by activities or
whether some of the sounds come from some other space.

THURSDAY 23 MARCH 2006

Third session at the dementia centre. Lots of old people at
the dementia day centre today. We all sing songs and make
drawings. One lady tells me she has not slept with a man for
a very long time, not since her left leg was removed. She then
removes her leg. She says she fancied the surgeon who
removed her leg. "He had lovely blue eyes."

FRIDAY 24 MARCH 2006

Travel to Middlesborough and back to discuss with
Middlesborough Institute of Modern Art, a day-long public
art event to raise awareness of the new museum in the run up
to its opening. We decide on an art fair inviting everybody to
sell their work to be called "Make Your Own Damn Art Fair".

SUNDAY 26 MARCH 2006

Disturbing session with artist Victor Mount at a *Hearing
Voices* group in Ilford organised by occupational therapist,
Jackie Ede, for our mental health project. The participants in
the group are clearly helped by sharing what is happening to
them but some of their stories are terrible. Most of the people
in this group have suffered horrible abuse.

Bob and Roberta Smith's
passport with a Chinese visa.

Help I'm Drowning In Piss.
One of Victor Mount's
contributions to the *Hearing
Voices Seeing Things* exhibition
at The Serpentine, 2006.

MONDAY 10 APRIL 2006

Pick up visa from the Chinese embassy. Jessica Voorsanger and I have been awarded some money to take our kids as the *The Family Art Project*, to China. *The Family Art Project* is an ongoing series of works that seek to bring the activities that occur in the education departments of galleries into the main curatorial programme of those galleries. Jessica and I think that seeing the development of ideas and then watching them being realised is at least as interesting as seeing the final product.

Before the family flies out there, I will do a reconnaissance mission to meet artist groups, families and schools. Our slogan for the project is "Let the Kids Decide". Its perverse utopian message got us into trouble with the Chinese workers at The British Council, reminding them of the dark days of the Cultural Revolution, and they thought it would be foolish to display it.

FRIDAY 21 APRIL 2006

Meet Jo to travel to Southend to continue our exploration of
possible sites. We rendezvous with David Wright at Southend
council offices where we are to be escorted on our tour by a
local council officer. We jump into his 4x4, and instead of
heading to the seaside at Southend, ten minutes later we are
in Canvey Island. The officer is determined to show us the
area we missed on our previous trip. He takes us just west of
the town of Canvey along a spit of land where small pleasure
boats are moored.

He parks and we get out. It is a beautiful clear fresh spring day.
I am happy he has brought us here, and the journey confirms
to me how romantic Canvey Island is when the sun shines.

Next he shows us a number of parks and playing fields on the
fringes of Southend, which to my mind are boring municipal
spaces. The last site he outlines the council are interested in
having us work with, is another council estate called The
Queensway Estate. He doesn't take us there but simply points
to four tower blocks located near the station. We walk around
the site. The 1960s architecture of the place is really futuristic.
The blocks are linked by elevated walkways, which the
architect, you might imagine, conceived as meeting places for
the residents. Every wall and fence on the site is gently
curved, taking you around the site in a series of arcs. At one
point, the walkway opens out to accommodate a forlorn
building, which is boarded up. This Jo tells me is the
community centre. I have no idea what an artist could do with
this place given our limited budget. The site could clearly do
with several million pounds of investment but it's a really
great building. I resolve to get the others excited about The
Queensway Estate being chosen as one of our sites. Like the
other two council estates, what I think of as increasingly
important is that there are people living here, who will at least
get something from the public money we are going to spend.

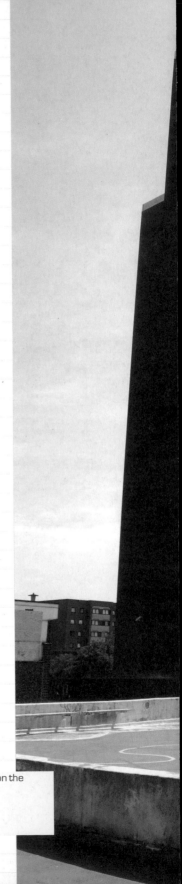

The Malvern building on the
Queensway Estate.

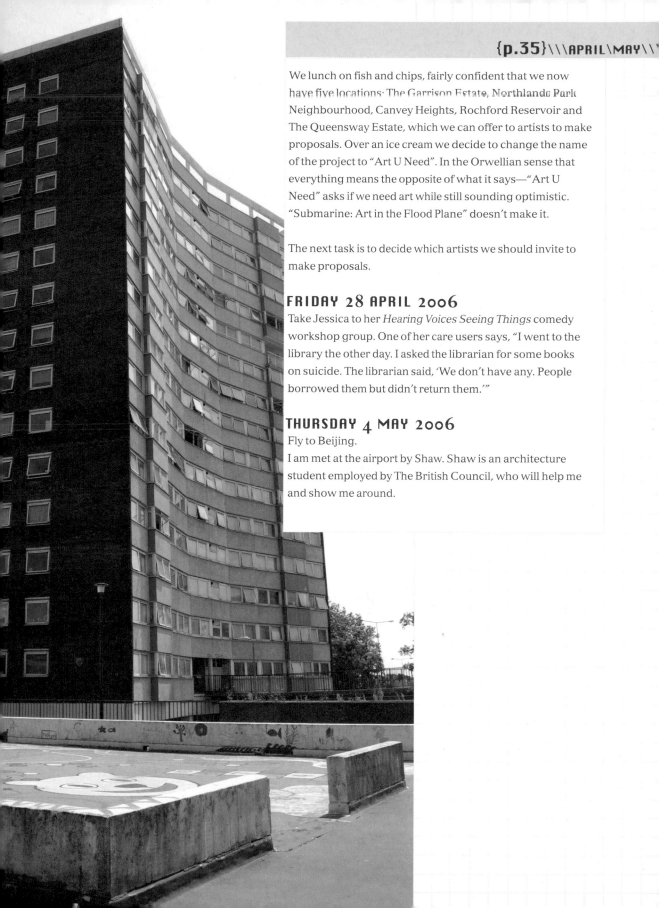

We lunch on fish and chips, fairly confident that we now have five locations: The Garrison Estate, Northlands Park Neighbourhood, Canvey Heights, Rochford Reservoir and The Queensway Estate, which we can offer to artists to make proposals. Over an ice cream we decide to change the name of the project to "Art U Need". In the Orwellian sense that everything means the opposite of what it says—"Art U Need" asks if we need art while still sounding optimistic. "Submarine: Art in the Flood Plane" doesn't make it.

The next task is to decide which artists we should invite to make proposals.

FRIDAY 28 APRIL 2006

Take Jessica to her *Hearing Voices Seeing Things* comedy workshop group. One of her care users says, "I went to the library the other day. I asked the librarian for some books on suicide. The librarian said, 'We don't have any. People borrowed them but didn't return them.'"

THURSDAY 4 MAY 2006

Fly to Beijing.
I am met at the airport by Shaw. Shaw is an architecture student employed by The British Council, who will help me and show me around.

FRIDAY 5 MAY 2006

Without Shaw I go to the opening of an exhibition in Beijing's art district. I meet a young Chinese sociologist who is studying the "Marketisation of Art in China". I ask her about the work on show. She says, "Chinese artists make art like the monkey in the zoo eats bananas." Art provides the look of freedom for liberals and Western collectors. The more free the Chinese artist appears, the more he or she is doing the state's work. I contemplate artists getting their hands dirty "doing the state's work" in relation to *Art U Need*. But then I contemplate artists getting their hands dirty in relation to the Medici.

SATURDAY 6 MAY 2006

I meet Shaw at The British Council. I tell him about the Chinese sociologist. He gets all serious and asks for her name? I suspect Shaw is a spy.

I ask Shaw if I can make a film of me interrogating him. He says, "It is a silly idea. If I were a spy why would I waste my time spying on you?"

SUNDAY 7 MAY 2006

I go to Tiananmen Square and end up in a conversation with a street seller. I decide to incorporate this conversation into a painting I am planning:

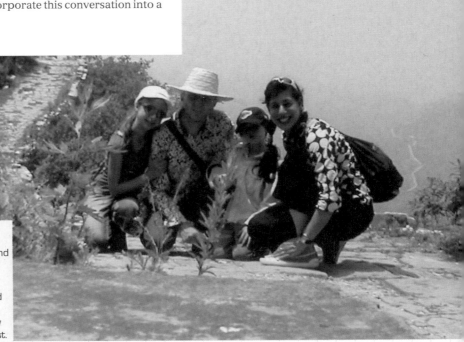

The Family Art Project on the Great Wall of China (from left): Etta, Bob and Roberta, Fergal and Jessica.

Fly to Beijing.
Signwriter's enamel on recycled wood and squid kite. Bob and Roberta Smith, 2006. Courtesy Hales Gallery, copyright the artist.

A GUY COMES UP TO ME AND TRIES TO SELL ME A MAO WATCH. THE HOUR AND MINUTES HANDS ARE MAO'S ARMS. I SAY "I WOULD RATHER WEAR A SWASTIKA." THE GUY SAYS "MAO WAS 80% GOOD AND 20% BAD." I SAY "THAT MAKES HITLER 99% GOOD BECAUSE HE KILLED A LOT LESS THAN THE 70 MILLION MAO DISPOSED OF." HE SAID, "LOOK MATE I DON'T WANT TO DISCUSS THE RELATIVE MERITS OR OTHERWISE OF HITLER AND MAO WITH YOU. I JUST WANT TO SELL YOU SOMETHING. HOW ABOUT A KITE IN THE SHAPE OF A GIANT SQUID?" I SAY OK, AND I PART WITH £7.

1.5.06 Fly to Beijing, I am met at the Airport by Shaw. Shaw is an architecture Student he will show me around and help me.

6 5 2005 I go without Shaw to an opening of an exhibition in Beijing's Art District, I meet a young Chinese Sociologist student who is studying the Marketization of Art in China. I ask her about the Art on Show. She says "Chinese Artists make art like the good monkey in the Zoo Eats bananas! They sell the appearance of freedom to the West, the more free the Artist looks the more they are doing the States Work."

8 5 2006 I go to Tianamen Square. A man comes up to me to sell me a Moa Watch. The minute and hour hands are Moas arms. I say I would rather wear a Swastika. The guy says "Moa was 80% good 20% bad." I say that makes Hitler 99% good because he killed a lot less than the 70 million Moa disposed off. He said, "Look mate I dont want to discuss the relative merits or otherwise of Hitler and Moa, I just want to sell you something How about a kite in the shape of a Giant Squid? I say Ok, and I part with £ 7.

7 5 2006 Meet Shaw at the British Council I tell Shaw about the Sociology Student He gets all serious and asks for her name. I suspect he is a spy. I ask Shaw if I could make a film of me interigating him? He says, it is a silly idea If I was a Spy Why would I waiste my time Spying on you?

10 5 2006 I go Shopping with Shaw I buy a poster of Moa and write Pol Pot's Dad on it then I put it in a pile in the next shop! Shaw is uneasy. I give up on my filmic interigation of Shaw Shaw is useless. Last night he marooned me north of the Art District after announcing saying he had met a special friend a young girl and he had to go off to do some bussiness. Short of tieing him to a chair and beating him with bamboo poles I dont think it will be an interesting film. All Shaw wants to do is ponce about with his twenty chinese mates.

MONDAY 8 MAY 2006

I go shopping with Shaw. We buy a poster of Mao and I write "Pol Pot's Dad" on it. Then I put it back and buy another. Shaw is uneasy.

Last night he took me to a party north of the art district and marooned me there. He said he had met a special friend (a young girl) and he needed to do some business. All Shaw wants to do is hang out with his trendy Chinese mates at art openings.

I give up on my idea for a film of me interrogating him. Short of tying him to a chair and beating him with bamboo poles it will not be an interesting film.

TUESDAY 9 MAY 2006

Travel to Shanghai to discuss *The Family Art Project* with Li Min School.

WEDNESDAY 10 MAY 2006

I receive an e-mail from Ingrid Swenson at PEER art space asking if I could devise a public art work for five sites around Shoreditch to be launched in August.

I think, blimey, that's short notice!

SUNDAY 14 MAY 2006

Return to London from Shanghai.

TUESDAY 16 MAY 2006

Fly to Turin to set up an exhibition of my work for Guido Carbone Gallery. Guido is very unwell and in pain at the opening. I make a piece numbering everything in the gallery with large figures, all sign-written. Number 15 is the gallerist. Guido jokes that on the price list he will charge "niente per Il galleriste", because he is on his last legs.

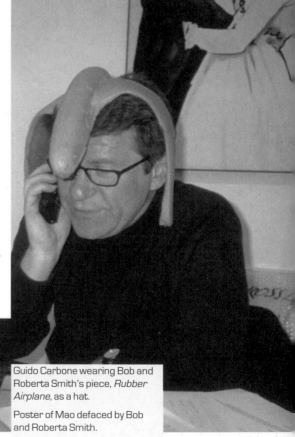

Guido Carbone wearing Bob and Roberta Smith's piece, *Rubber Airplane*, as a hat.

Poster of Mao defaced by Bob and Roberta Smith.

FRAGI

POL POT'S DAD

FRIDAY 19 MAY 2006

Return to London. There is a message from the Carbone Gallery to say Guido has died.

I am really upset. Over the years I have made three shows with Guido, we barely sold anything, and yet he went on believing in Bob and Roberta.

SATURDAY 20 MAY 2006

I meet with Ingrid Swenson at PEER.
I tell her that for some time, I have wanted to make a piece of work where I celebrate local businesses that exist in the same street as an art gallery. My intention is to say gently that shops are artworks and shopkeepers are artists. We come up with a plan to locate five businesses in Hoxton Street and make five large signs for each one using traditional sign writers. The project will be called *Shop Local*. There will be a *Shop Local* shopping bag to mark the event.

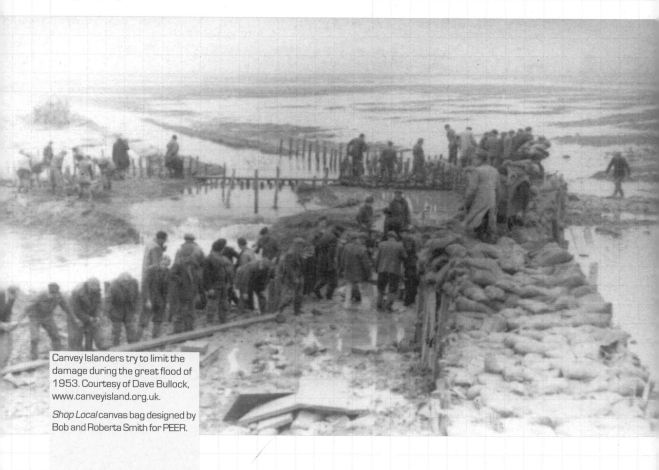

Canvey Islanders try to limit the damage during the great flood of 1953. Courtesy of Dave Bullock, www.canveyisland.org.uk.

Shop Local canvas bag designed by Bob and Roberta Smith for PEER.

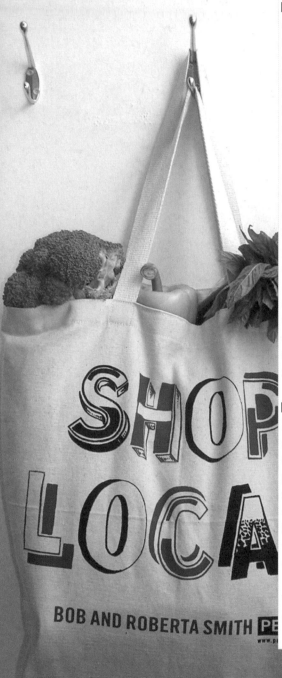

WEDNESDAY 24 MAY 2006

Jo and David have developed a way of conducting meetings about their art projects which gently gets people on board while at the same time letting them inform us about the local history and needs of the area. While I was away in China Jo has arranged a meeting with a steering group at each location. The steering group consists of local residents, an arts officer from the council (if there is one), local churches and basically anyone who is interested.

Today we meet at Canvey Island. My job is to appear authoritative and get the steering group excited about the project. I am daunted about the prospect of five such meetings but actually I really enjoy hearing about the history of Canvey Island, although things get rather gloomy when everyone starts discussing the terrible flood of 1953, when 56 people drowned. At the end of the meeting a date is arranged to interview a shortlist of artists. Timescales are short and it is agreed Commissions East and myself will come up with the shortlist, although I am reminded by David that we will have to conduct an open submission for at least two of the sites. This is public money we are spending and all decisions must be accountable!

WEDNESDAY 31 MAY 2006

Meeting in the evening with The Garrison Estate steering group. At the meeting there is a man with a small dog in a canvas bag. I am puzzled when, after explaining how the project could be realised in all sorts of ways, including film, some kind of event, a book, a piece of writing, a series of objects commissioned by residents, as well as architectural interventions, sound works and even music—one man says: "The only local stone is chalk and that will just be vandalised on the first night if it isn't washed away!"

What is striking at The Garrison Estate is how proud everyone is of their local history and the wonderful museum located there.

Jessica Voorsanger and her
Lucky Star Lucky Dip stand at the
Art Car Boot Sale.

SUNDAY 4 JUNE 2006

Scorching day spent at the Brick Lane Art Car Boot Fair. Everyone including Gavin Turk and Sarah Lucas sell their art trinkets. I do a performance that relates to my recent trip to China.

Thousands of people attend. The event is an astonishing success. Maybe this is the new face of public art—everyone having fun in the sunshine, not someone contemplating a bronze lump in a field in the rain.

MONDAY 5 JUNE 2006

Steering group meeting at Rochford. Really enthusiastic event. I enjoy talking to the representative from the model railway club who tells me an extraordinary story about a 'whispering post' where the residents of Rochford were invited to inform on one another to the local landlord. Apparently the whispering post still exists in a Rochford front garden.

SUMMER 2006

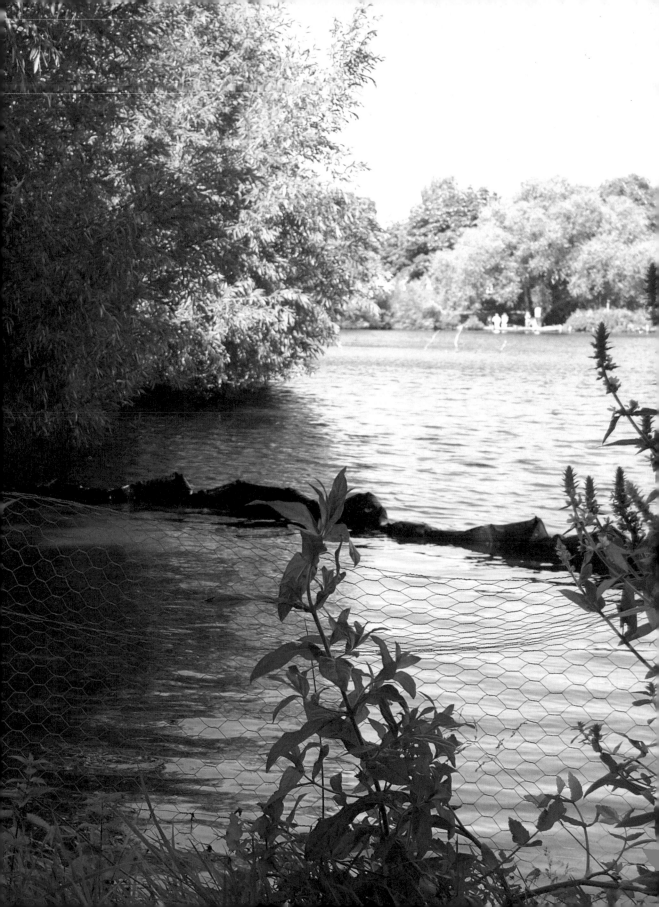

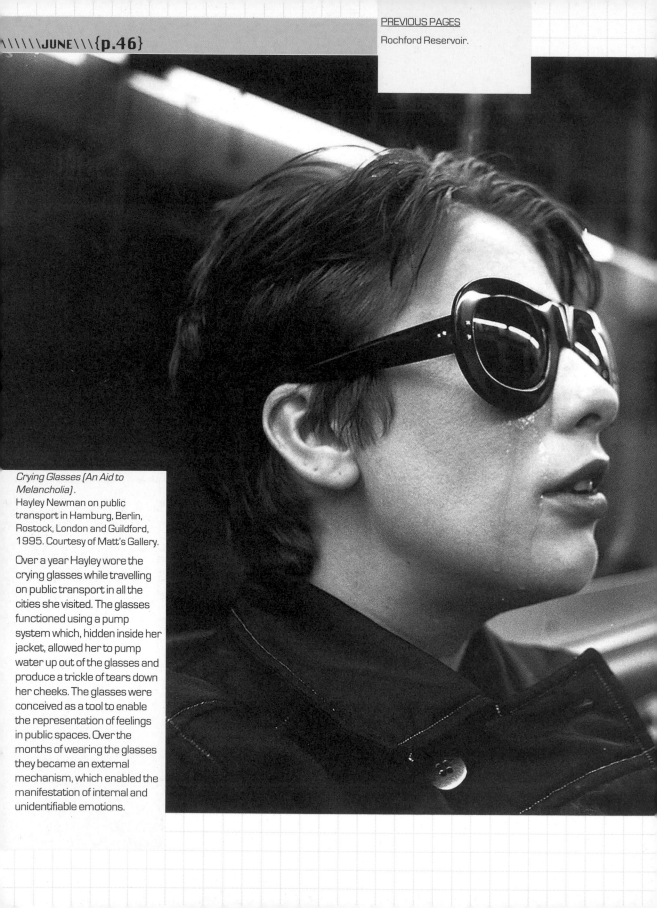

PREVIOUS PAGES
Rochford Reservoir.

Crying Glasses [An Aid to Melancholia].
Hayley Newman on public transport in Hamburg, Berlin, Rostock, London and Guildford, 1995. Courtesy of Matt's Gallery.

Over a year Hayley wore the crying glasses while travelling on public transport in all the cities she visited. The glasses functioned using a pump system which, hidden inside her jacket, allowed her to pump water up out of the glasses and produce a trickle of tears down her cheeks. The glasses were conceived as a tool to enable the representation of feelings in public spaces. Over the months of wearing the glasses they became an external mechanism, which enabled the manifestation of internal and unidentifiable emotions.

TUESDAY 27 JUNE 2006
Interview of artists for Rochford.

I miss my 9:00 AM train and turn up as the first person is introducing himself. All the interviewees have done so much research on the area that I feel guilty to have put them all through this process to eventually choose just one. In truth they all would have been good. It becomes apparent that David, Jo and I have done our job in shortlisting the candidates. It's really important now for the local residents to tell us which artist they think will work best in their area. Each artist gives a short presentation and then there are questions from both sides. The locals choose Hayley Newman. Hayley is a performance artist whose performances are often funny and always very sculptural and oddly formal. She showed the group a piece of work where she filled a bus full of fuel and people and drove it around Milton Keynes until the fuel ran out. I wondered what our group would make of this piece but they loved it. I was very excited by this choice, and we were off to a brilliant start.

A quick, rather poisonous buffet then off to the interview at The Garrison Estate. Another four great artists. The group chooses Jane Wilbraham. Jane has great experience of working with groups of people to produce amazing sculptures. She shows us a piece, where she made replica of a meat counter out of cardboard and persuaded a supermarket to display it in their store. Her work is always quietly political and gently subversive. It involves the subtle manipulation of the social realm in ways that are rooted in the connection between working people and their surroundings, what they produce and eat....

At the end of the discussion about Jane Wilbraham the same man who pessimistically predicted that we would end up with a bit of vandalised chalk exclaims excitedly, "We have lit a firework, we could end up with a road show, a film, a novel or even a musical! We must stand back and see what happens."

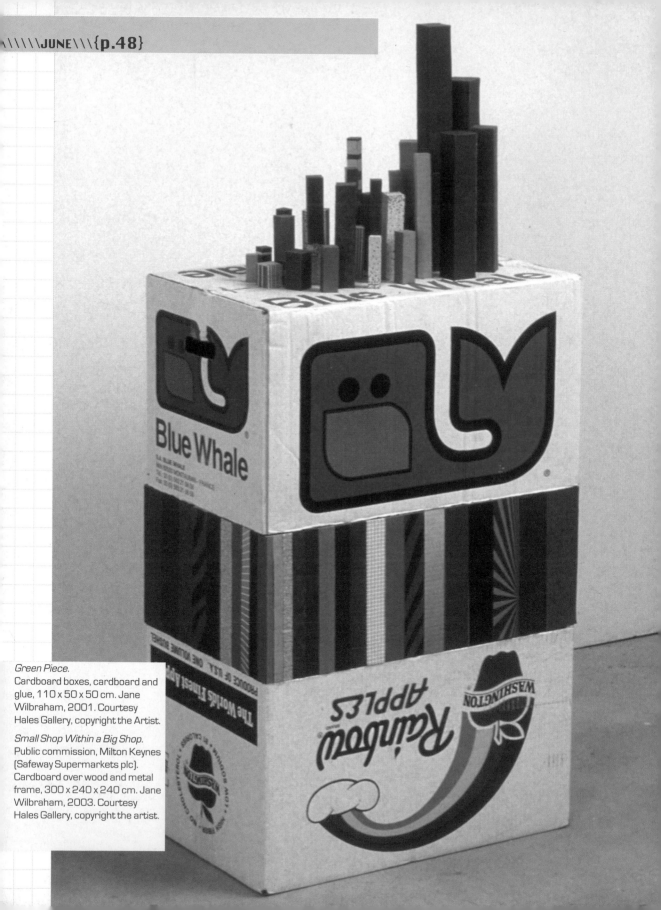

Green Piece.
Cardboard boxes, cardboard and glue, 110 x 50 x 50 cm. Jane Wilbraham, 2001. Courtesy Hales Gallery, copyright the Artist.

Small Shop Within a Big Shop. Public commission, Milton Keynes (Safeway Supermarkets plc). Cardboard over wood and metal frame, 300 x 240 x 240 cm. Jane Wilbraham, 2003. Courtesy Hales Gallery, copyright the artist.

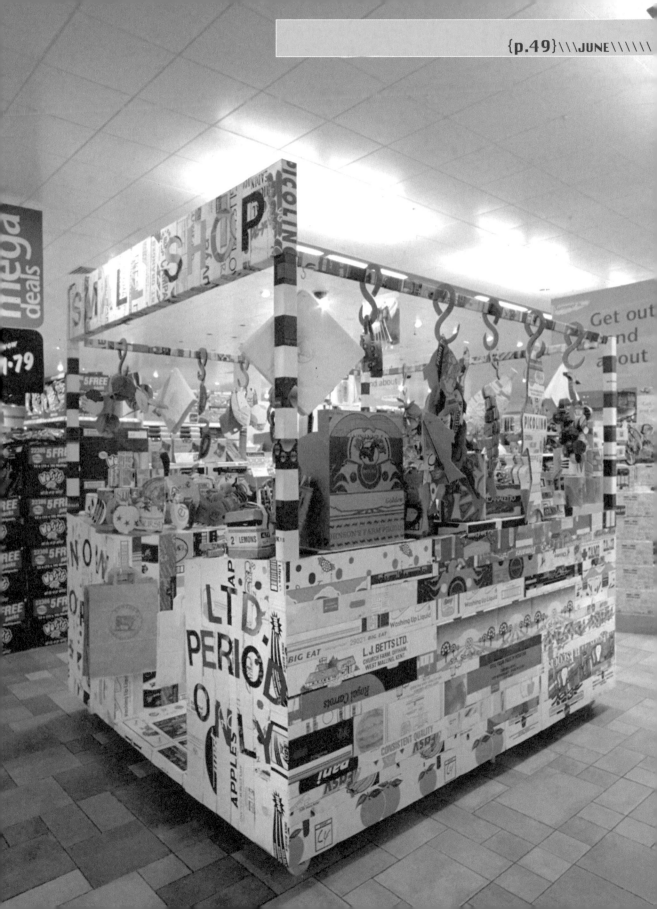

THURSDAY 29 JUNE 2006

Canvey Island interviews.

The whole steering group is crammed into a hot, airless room under a flat roof in a community centre called "The Paddocks". I am not aware of some of the artists on the shortlist. All the proposals seem quite surreal. One man, who I think is fantastic, suggests building an underground world beneath the surface of Canvey Heights. Again, it's hard to choose but there is something really authoritative and serious about the work of Lucy Harrison that we all appreciate. Lucy Harrison's practice as an artist is as much about research as it is about making things. She comes armed with small library of pamphlets which are updates of various former Soviet satellite capitals where she has gone in search of the plinths upon which once stood statues of Marx and Lenin. In another work the panel likes, she has gone through all the art books in the art school where she teaches stealing the notes made by students scribbled in the margins. Her work is really about ghosts— ghosts of ideas that somehow maintain a resonance by finding forgotten places to haunt. She is perfect for Canvey Island.

From *Guided Tour; Riga.*
A series of texts and photographs documenting walks in Riga, Latvia following the tours outlined in a Soviet era guidebook. Lucy Harrison, 2005.

Maria Debrer

A Guide

RIGA

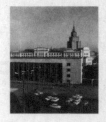

Go round the church and you will find yourself in a quiet little backstreet- Cesu Street. Here at No 17 is the Lenin Museum, opened in 1961.

Lenin Museum on Cesu Street

FRIDAY 30 JUNE 2006

The Family Art Project flies to China.
This could be a book of its own. Any offers folks?

We discover that Chinese people have old people's parks
where Tai Chi equipment is installed for the old to keep
supple. Art that keeps you fit!

Our slogan "Let the Kids Decide" proves highly controversial,
but even more problematic is the idea of "One Child Policy" in
relation to *The Family Art Project*. We realise the most basic
freedoms we take for granted are denied to Chinese families.
We turn up with our two kids and our project, which muses
upon liberal freedoms based on ideas rooted in the 1960s, and
are struck by the way that everything is politicised. I make a
video piece, in which I declare from the top of a tower block
that "with One Child Policy there will be no aunties or uncles
or cousins let alone brothers and sisters", and that "the only
family a Chinese person will have will be the state. One Child
Policy is nothing to do with population growth but everything
to do with social control."

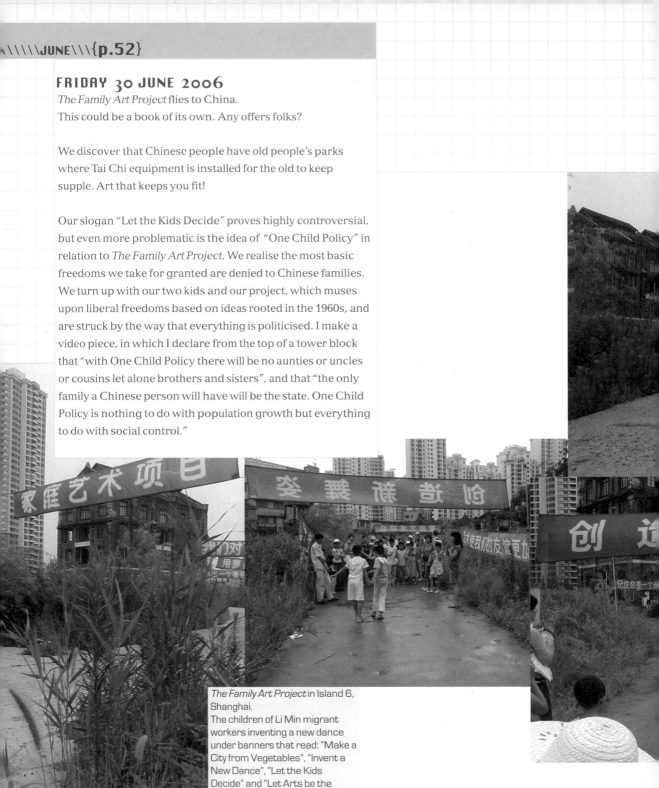

The Family Art Project in Island 6,
Shanghai.
The children of Li Min migrant
workers inventing a new dance
under banners that read: "Make a
City from Vegetables", "Invent a
New Dance", "Let the Kids
Decide" and "Let Arts be the
Evergreen Language that Unites
the People".

We do an art project with an amazing migrant workers' school, which is set up to teach the kids of workers in China's burgeoning coastal economy. The kids of migrant workers do not have the same benefits as other Chinese children. Migrant workers live outside the rules. They tend to have two or three children and are generally discriminated against. In our project we get the migrant workers to make cities from vegetables and paint pictures of their heroes.

Our children, Etta aged 11 and Fergal aged six, have a wonderful time. The food is great, but there are huge questions about the role of art in contemporary China. While I am in China I am asked to prepare a talk about FREEDOM for a one-day conference on John Stuart Mill at Tate Britain. I resolve to talk about China.

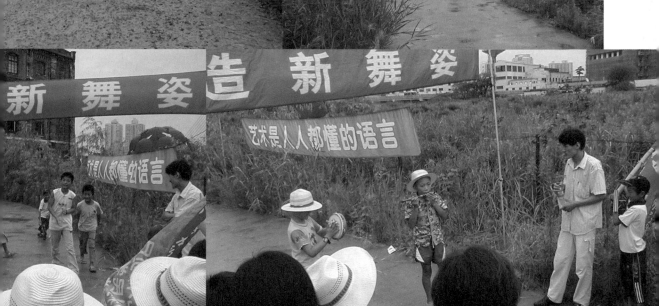

TUESDAY 1 AUGUST 2006

The Turner Centre in Margate e-mails me to ask if I could make a public artwork for Margate High Street to open in early September. I ask myself what is it about The Thames Estuary, public art and Bob and Roberta Smith at the moment? I must locate that meme and alter it so it has more exotic aspirations.

Return from Shanghai to London.

FRIDAY 11 AUGUST 2006

Steering group meeting, Northlands Park Neighbourhood, Basildon. On the steering group are two local artists. They are very concerned that we give someone from the area the opportunity of making a work at Northlands Park. I try to reassure them that with the Northlands Park Neighbourhood and The Queensway Estate in Southend we will be able to advertise in *Artists' Newsletter* and whoever wants to apply will be able to. We are reminded by the steering group that Northlands Park is a very deprived community and apathy will be a problem.

SATURDAY 19 AUGUST 2006

PEER holds a party to celebrate the *Shop Local* project at The Drawing Room. Both groups of signwriters come to the event and there is a concert where Frog Morris, Leigh Clark and a fantastic guitarist songwriter called Jemma Freeman play as well as the Ken Ardley Playboys (my band). We all have fun.

HOXTO
LIGHTBULBS
CLOCKS TUR
SANDWICHMAK
SATELLITE
REPAIRS
1 0 4 H
S H O

RON'S EEL AND SHELL FISH
WHELKS PRAWNS SMOKED HADDOCK ROLL MOPS
S E A F O O D P I E C E S
S M O K E D S A L M O N
E V E R Y F R I D A Y A N D S A T U R D A Y
H O X T O N S T R E E T M A R K E T
S H O P L O C A L

WEDNESDAY 30 AUGUST 2006

9.00 am.

I take a train to Cambridge to look at slides sent in for the Northlands Park Neighbourhood and Queensway Estate projects. It's a long slog but eventually we arrive at a shortlist for each site. A woman from the Arts Council attends the meeting, I guess, to check we are spending their money correctly.

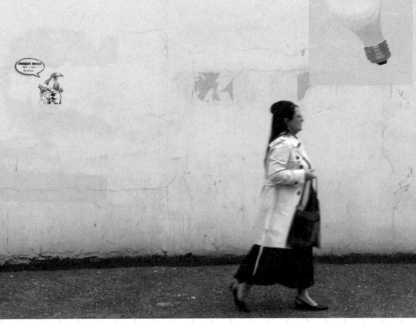

Shop Local.
Signs designed by Bob and Roberta Smith advertising sole trader businesses on Hoxton Street. Commissioned by PEER, 2006.

SUNDAY 3 SEPTEMBER 2006

Wonderful day in Middlesborough at the "Make Your Own Damn Art World" event. The best part of it was seeing the Baltic Gallery in Gateshead with their stand next to the Middlesborough Arts Society stand. The idea of a fair for art where money would change hands was a bit unrealistic. Very few people have any money, but they do have goodwill by the bagful. We make monopoly money, which is called "tokens of respect". All punters get "tokens of respect", which they can give to artists whose work they like. This works brilliantly. Some artists begin offering 'art services' in return for tokens of respect. I find an artist whose work I really like and buy two paintings.

TUESDAY 5 SEPTEMBER 2006

There is a meeting about the *Hearing Voices Seeing Things* project at The Serpentine Gallery about how best to recreate the Leytonstone Centre for Contemporary Art (LCCA) at Kensington Gardens. The LCCA is a shed in our garden where Jessica Voorsanger and I put on art shows. The LCCA will be the venue for the work made with the Mental Health Care Users from North East London's Mental Health Trust.

During the meeting, I get a call from BBC Essex Radio about *Art U Need*. Walking around in the blistering sunshine in central London suddenly I am live on-air with a journalist. He says, "*Art U Need*? How much is it costing?" I tell him it's going to cost at least the price of two kidney machines. He says "Wouldn't the money be better spent on a kidney machine?" I tell him in the past, kidney machines used to be really interesting-looking with all sorts of pipes and taps, but these days they are just a big white box that bleeps. Anyway they would still get ruined if you left them out on a roundabout. I tell him money for the NHS has already been allocated. When critics of public spending on the arts bring up the kidney machine argument it's time to mention how much a missile costs? I ask him "What do you want? An art work, a kidney machine or a bomb dropped on a village in Iraq?" *Art U Need* is about getting people to look above the parapet of existence and to see how the land actually lies. Art is about freedom. I tell him *Art U Need* is going to give a voice to people that are usually told to shut up and take it.

I end up getting totally carried away and begin to sound like a preacher. "Art is like religion or music or great writing or singing, it's a way of contemplating who we are and what we are about. Those who deny people art want people to go to work, come home, watch telly and play stupid video games and die and never ask a question!" There is silence on the end of the line. Then in a cheesy local radio voice I hear, "Well moving on, today there is controversy on Canvey Island about a missing dog, over to John…."

In the evening there is an opening for a show of my work at PEER that relates to the *Shop Local* project. Lucy Harrison who has already visited Canvey Island to get to know people tells me one of her Canvey contacts heard the radio show and remarked on the zeal of my enthusiasm for art.

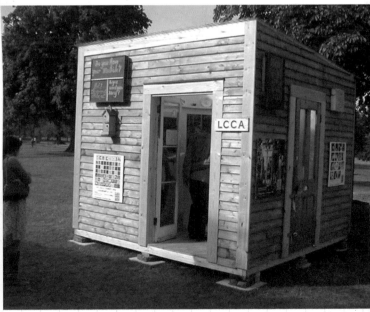

The lost dogs from Canvey Island.

A token of respect designed for the "Make Your Own Damn Art World" event at the Middlesborough Institute of Modern Art.

The Leytonstone Centre for Contemporary Art (LCCA), relocated from Bob and Roberta Smith's garden to the grounds of The Serpentine Gallery.

WEDNESDAY 6 SEPTEMBER 2006

I curate a series of performances to coincide with the opening of *HOW TO IMPROVE THE WORLD: 60 years of the Arts Council Collection,* at The Hayward Gallery.

Jessica dresses up as David Hockney and makes portraits of people as palm trees. She turns a corner and runs into David Hockney. He is not amused.

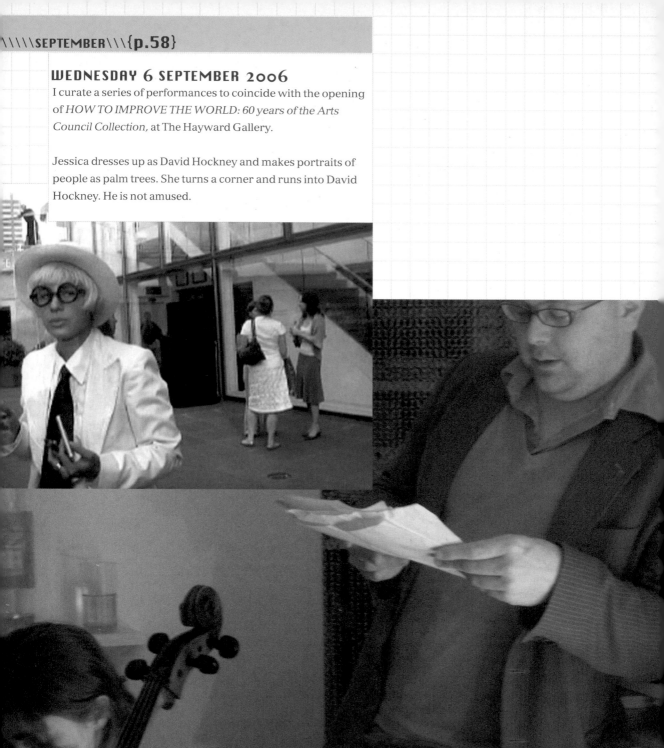

MONDAY 11 SEPTEMBER 2006

AM

Jo and I meet on the train to travel to Basildon then on to
Northlands Park Neighbourhood by taxi. We meet David
Wright and a somewhat sceptical steering group. We
cram into a long narrow room in the community centre to
interview two candidates chosen from slides a week and a
half ago in Cambridge. The group chooses Andrea Mason.
Andrea is a writer and general agent provocateur. She is
incredibly dynamic in the interview, suggesting all sorts of
strategies for engaging people—ranging from dog breeding
to teenage villages, to shops as places of safety and tree
hugging sessions. One idea is a t-shirt for kids declaring
"I am hard to reach." She is very witty and has really done
a lot of thinking about how people live on the estate. It is
a brilliant performance.

What no lunch?!

LEFT TO RIGHT

Jessica Voorsanger as David
Hockney at the opening of *HOW TO
IMPROVE THE WORLD* at The
Hayward Gallery.

*King Street Rocks Salon—The
Musical One*
This was the first of a number of
salons organised by Andrea Mason.
It featured performances by poets,
writers and musicians as well as a
karaoke room and a screening of
Cabaret. Andrea Mason, 2004.

Writer Andrew McDonnell
performs with an accompaniment
by Michaela Nettell on cello.

A poetry recital by Fiona Curran.

PM

More interviews, this time at The Queensway Estate in Southend. Because the council have closed the community centre there is nowhere for our group to meet. I think of donating the council a few copies of Orwell's *1984* so that they can reflect on the uses of language. You would suppose if you close down a community centre, you would have the wit to see you were closing down the centre of a community and thus causing a bit of alienation.

We convene in a tiny cork-tiled room in the library. The state of neglect of The Queensway Estate makes me angry. It is as if society has agreed that nothing good will happen for the people living there. The fabric of the buildings urgently needs a major overhaul. We can offer around £30,000 for our art project but it's nothing really. On the steering group there is a courageous man who lives on the Estate who has fought tooth and nail for improvements to the buildings. He has been part of the creating of some beautifully planted gardens at the foot of the buildings.

Milika Muritu is chosen for the project. Mili is a sculptor. Her work is abstract but always has a subtle element of human interaction built into its conception. She often makes architectural spaces for people to inhabit. She is very interested in the laundry rooms, as they are communal spaces located on every floor of the blocks. They could be seen as a kind of gift to the residents by the architects, yet it's a weird idea really and not many of them are used for drying laundry. She puts into words what has become an underlying theme of all the proposals that have been successful and that is that public art is best done by stealth.

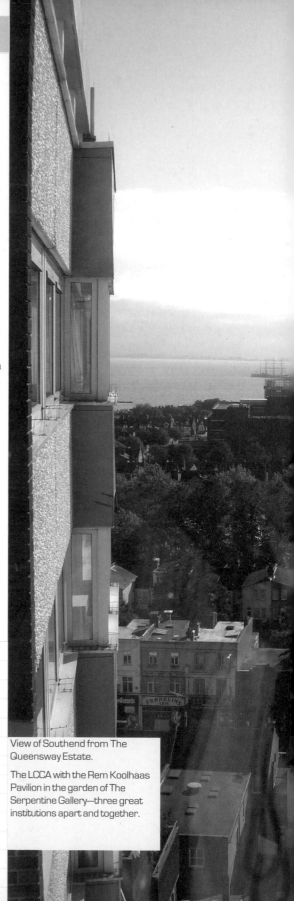

View of Southend from The Queensway Estate.

The LCCA with the Rem Koolhaas Pavilion in the garden of The Serpentine Gallery—three great institutions apart and together.

SATURDAY 16 SEPTEMBER 2006

Opening of the LCCA's *Hearing Voices Seeing Things* exhibition. The aim of this project was to get artists and care users of northeast London's mental health trust to come together to explore ideas about therapy and 'normal' people's perceptions of mental health. The project has resulted in an exhibition 'of sight' in The Serpentine Gallery's garden. The whole event is a profound experience, as it places me in the privileged position of being able to see how both groups of people valued creativity.

I am amazed at how many people show up. Jessica has organised a comedy night in the Rem Koolhaas Pavilion. Lots of service users show up, and it's a wonderful night for us, Sally Tallant and Louise Coysh at The Serpentine, but really it's a triumph for Jackie Ede, the occupational therapist, who initiated the whole project. Wonderful booze up at the Polish Club afterwards.

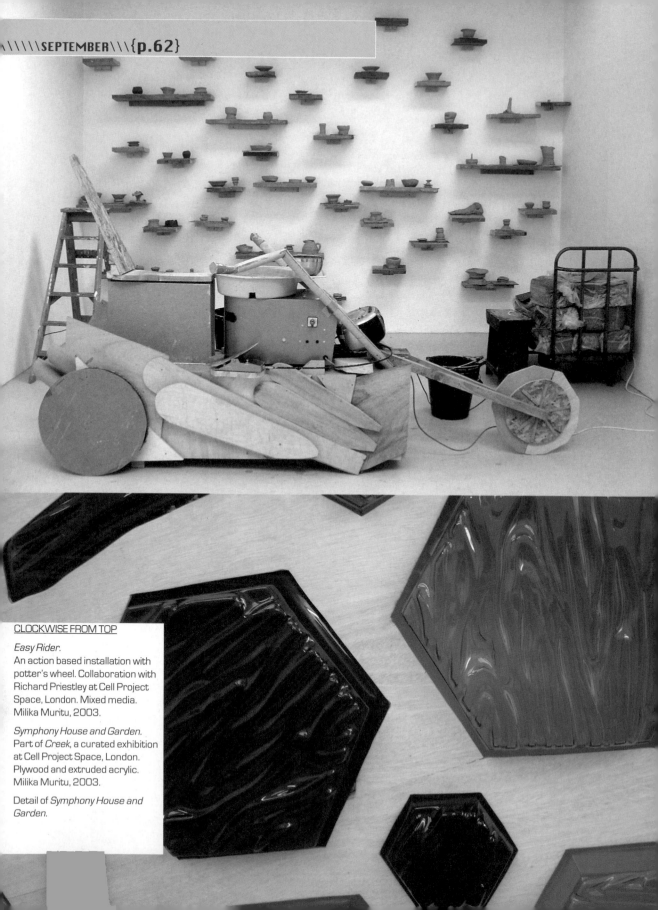

CLOCKWISE FROM TOP

Easy Rider.
An action based installation with potter's wheel. Collaboration with Richard Priestley at Cell Project Space, London. Mixed media. Milika Muritu, 2003.

Symphony House and Garden.
Part of *Creek*, a curated exhibition at Cell Project Space, London. Plywood and extruded acrylic. Milika Muritu, 2003.

Detail of *Symphony House and Garden.*

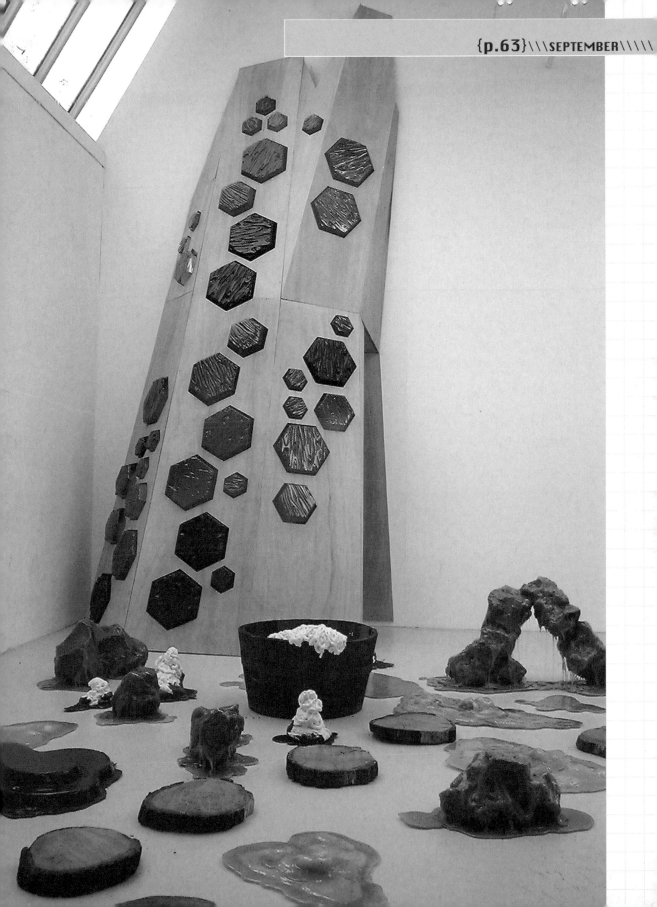

FRIDAY 29 SEPTEMBER 2006

Opening of my banners project in Margate High Street called *Should I Stay or Should I Go?* curated by the Turner Centre.

SATURDAY 30 SEPTEMBER 2006

Attend the burning of a large Anthony Gormley sculpture in Dreamland in Margate. Best thing he has ever done. Feel queasy at the bombastic claims made for this event. The next day Gormley writes in *The Observer* that this was his way of dealing with 9/11.

SATURDAY 14 OCTOBER 2006

Hayward Gallery.

Attend the most moving work of public performance I have ever seen. Gustav Metzger, who has spent 78 years fighting the system, escaping the Nazis, confronting the art world's embrace of capitalism, campaigning for the environment, and creating a debate about art and the media every bit as complex as anything written by Noam Chomsky, recreated a performance where he destroyed a nylon painting with acid in an act of 'auto-destruction'.

PREVIOUS PAGES

Shop Local.
Sign on London's Brick Lane advertising the Discoveries Shop. Designed by Bob and Roberta Smith, commissioned by PEER, 2006.

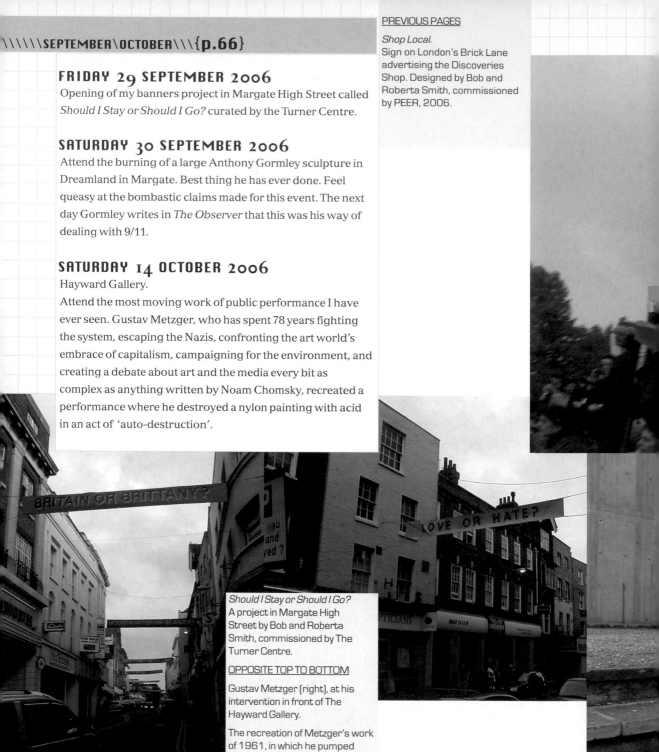

Should I Stay or Should I Go?
A project in Margate High Street by Bob and Roberta Smith, commissioned by The Turner Centre.

OPPOSITE TOP TO BOTTOM

Gustav Metzger (right), at his intervention in front of The Hayward Gallery.

The recreation of Metzger's work of 1961, in which he pumped hydrochloric acid over sheets of nylon as an act of 'auto-destruction', intended as a demonstration against war, capitalism and the commodification of art.

WEDNESDAY 1 NOVEMBER 2006

Meet David and Jo at the offices of Theresa Simon who is a kind of art world press agent Commissions East have employed to publicise *Art U Need*.

We have appointed five women artists. We discuss why this has happened. In the end I conclude that women are better artists than men.

The philosopher Sadie Plant says that cyberspace is a female space. This statement is based upon the fact that women invented and control the technologies that cyberspace depends on. She says the Internet is unique because it is open, democratic and non-hierarchical. I muse upon the fact that contemporary art is now not so much about individuals' visions but about the dialogue between people. It seems art could aspire to be like Sadie Plant's female cyberspace. QED women are better artists than men because they don't depend upon hierarchies for their power, they are better stewards of society and their organisational skills are more advanced. In effect they are more useful as artists. The publicists like this idea (but maybe that's because all the publicists are women), and we agree to put an ad in *Art Monthly* declaring this apparent truth.

MONDAY 6 NOVEMBER 2006

Hayley Newman wrestles comedian Simon Munnery to the ground in Bethnal Green Working Men's Club in a homage to maverick comedian Andy Kaufman, organised by Sally O'Reilly and Mel Brimfield.

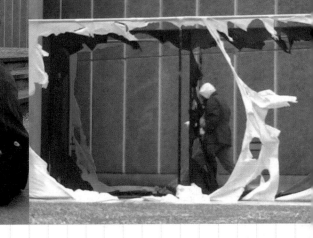

WEDNESDAY 8 NOVEMBER 2006

Hayley Newman's proposal for Rochford involves a group of people throwing a sculpture into the reservoir in parts and then having another group retrieving the sunken parts and putting the work back together. Today she has arranged for a group of local divers to do a reconnaissance dive in the reservoir. I get a text to say the dive has had to be cancelled due to fears about Weil's Disease.

FRIDAY 1 DECEMBER 2006

I have organised an *Art Peace Camp* at a gallery in Brick Lane. The idea is to invite everyone, whether they are an artist or not, to give us their vision of peace. The idea is popular, and the exhibition rapidly grows into a show of around 300 works ranging from people off the street, to Turner Prize winner Wolfgang Tillmans. The opening is wild. David C West comes dressed as a dog (*The Dogs of War*) and Mark McGowan sits outside with his hands in the air singing the Bob Dylan song "Blowing in the Wind". He plans to do this for two weeks. Mark once rolled a peanut to 10 Downing Street with his nose as a protest about the non-existence of student grants. A band I love called The Fucks play. It's a real party. Jess and I have a babysitter so we both drink too much.

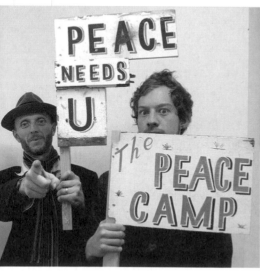

LEFT TO RIGHT

Bob and Roberta Smith with George Barker, bass guitarist of The Fucks at the Peace Camp at the Brick Lane Gallery.

The entrance to Canvey Heights, where The Rendezvous Club meet on the first Sunday of every month.

Screengrab from a website set up by residents of Canvey Island in memory of the concrete barge that resided on Canvey Island, until it was destroyed in 2003.

SATURDAY 2 DECEMBER 2006

It's not that I don't know where I am, the problem is I don't know who I am. I realise I have fallen asleep on the upstairs landing and that I am Bob Smith. Terrible hangover.

SUNDAY 3 DECEMBER 2006

Half a Dead Dog.

Meet Lucy Harrison at West Ham Station and drive to Canvey Heights for the inaugural meeting of The Rendezvous Club, due to start at 2:00 PM. Lucy seems to have spent most weekends down in Canvey researching her project. She has been offered a seaside bungalow to stay in, and infiltrated the Conservative Club. She has also befriended the manager of Dr Feelgood, the highly influential band, whose stripped down sound was taken as a benchmark for the whole of the 1970s punk scene.

Lucy's project revolves around finding a kind of local history that is idiosyncratic, eccentric and deeply personal. The Rendezvous Club is a walking club, in which Lucy hopes to focus on a different discussion each time. Today's topic is 'nostalgia'. The information Lucy gets from this research and other forays into the secret life of Canvey Island will be turned into information plaques, which will be located on Canvey Heights. She has found a local signwriter called "Bob the Brush" who will make the signs. There will also be an audio tour.

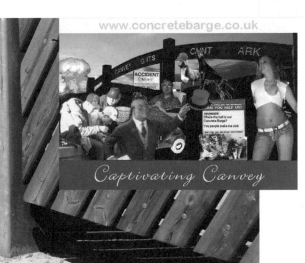

www.concretebarge.co.uk

Captivating Canvey

We meet at the gates of Canvey Heights and walk around the site admiring the view. Lucy gives us a brilliant map of the area with points of special interest such as: "the fence near the roundabout at Mitchells Avenue where a new pathway has been made by children fetching their balls through the hole", and the "viewing point for Longhorse Island where Chris Fenwick scattered the ashes of his friend, Lee Brilleaux, lead singer of Dr Feelgood". Lucy points out to everyone where some local school children found half a dead dog. It's windy and brisk but the sky is blue. As the sun sets in the west it turns the big sky pink and The Thames Estuary silver. The party carries on, as Lucy has arranged an open-topped bus tour. I make my way back to London as I have set upon "Listening to the Radio for Peace" at The *Peace Camp*. I tune in to Radio 2 and end up listening to Dale Winton's "Pick of The Pops" for peace.

MONDAY 4 DECEMBER 2006

A diary arrives from Andrea Mason filled with fun things to do at the Northlands Park Neighbourhood. It's a wonderful production job, beautifully designed. She tells me it is to be distributed to the residents of the estate at their Christmas fair.

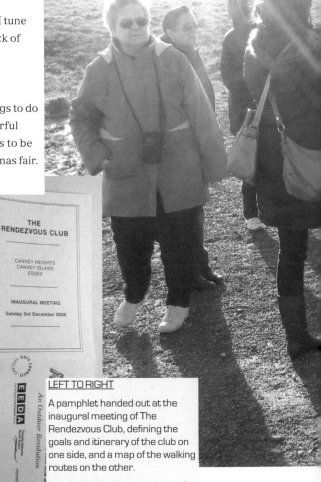

WALKING CLUBS ARE AT THE HEART OF THE CELEBRATIONS. OFTEN WITH SPECTACLES RARE

ITINERARY

Today's first walk is part of the itinerary below. If it is taking too long you may of course leave at any time! Depending on the weather, the plan is as follows:

2pm meet at gates of Canvey Heights. Up the hill past Kings Caravan Park. At the fork in the road turn left. The pathway around Canvey Heights will then be followed all the way round, taking in views towards Benfleet Creek, Leigh, the Yacht Club, Canvey Point, and Canvey Island.

On leaving the park we will then follow the concrete pathway with Kings on the right and Small Gains on the left. After going past the bus stop, we will bear to the left around the edge of the playing field.

We will go down Mitchells Avenue and reach the High Street, turning left we will go towards Leigh Beck and will reach the Transport Museum on the right. A number of people will then be able to have a ride on a vintage bus while the rest of the group are free to retire to the Admiral Jellicoe pub a favourite haunt of Canvey group Dr Feelgood (see right).

OTHER FAMOUS WALKS ON CANVEY

1. The Canvey Carnival

2. The Lee Brilleaux memorial walk

3. The route of the 'Cat Woman' in the Leigh Beck area

THE RENDEZVOUS CLUB

CANVEY HEIGHTS
CANVEY ISLAND
ESSEX

INAUGURAL MEETING

Sunday 3rd December 2006

Welcome to the first meeting of the Rendezvous Club.

The main purpose of the Club is to bring people together once a month to enjoy the open spaces of Canvey Island.

It is also hoped that the club will collectively contribute to the Canvey Guides project and you are requested to make additions to this map, taking the form of drawings, stories, anecdotes etc. and hand back to Lucy or Stan for inclusion at the next edition.

Each day there will be a suggested topic of conversation. Today's is *Nostalgia*.

YOUR SUGGESTIONS FOR THE JANUARY WALK

Tour Guide fact no. 1:
Claude Mirrors
The Claude Mirror was an optical instrument widely popular in the 18th and 19th centuries. It transformed the landscape into a scene reminiscent of the painter Claude-Lorrain. In areas such as the Wye Valley or the Lake District, tourists could purchase maps and mirrors at opticians, stationers and tourist attractions. At prescribed viewing stations they would turn their backs to the scene, hold up the mirror, and look at the framed and transformed view.

EEDA An Outdoor Revolution

ARTS COUNCIL ENGLAND

LEFT TO RIGHT

A pamphlet handed out at the inaugural meeting of The Rendezvous Club, defining the goals and itinerary of the club on one side, and a map of the walking routes on the other.

Lucy Harrison with members of The Rendezvous Club.

Portrait of Bob and Roberta Smith
Deirdre Borlaise (Bob's mum), 1990.

TUESDAY 12 DECEMBER 2006

I invite Mark McGowan onto my Resonance FM radio show. He sings "Blowing in the Wind", and his friend sings "Imagine". The effect is both moving and funny. I am amazed how clever his work is in the light of public art. Most critics assume that Mark invents these 'stunts' because he is publicity hungry, but actually each piece is a carefully crafted manipulation of a particular social space. I think he is a kind of social Donald Judd.

WEDNESDAY 13 DECEMBER 2006

Phone call from Roberta. Our mother has had a stroke. I get the train up to York. It is a warm day in London, considering it is December, but York is cold.

I get a Speedway cab to the hospital, it takes forever. Mum seems the same. She is lucky she can walk and speak but the bleed in her brain has had an effect I would never have imagined: my mother went to the Royal College of Art during the war. She paints and draws every day of her life. I present her with a sketchbook and some pencils. She says, "You know Bob, when I think I was an artist it amazes me, I don't want to walk around with spots of paint on my clothes anymore. I don't want to be an artist. I don't want to ever draw or paint again." I put the sketchbook back in my bag.

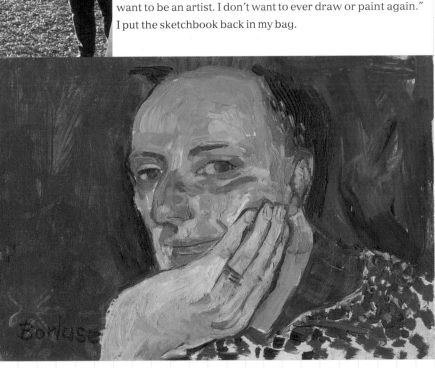

SATURDAY 23 DECEMBER 2006

Text from Hayley Newman inviting me to a dive in Rochford Reservoir on Christmas Eve at 9:30 AM. Unfortunately, I am in Ramsgate, and as we haven't yet bought a turkey or a tree, I decline the invitation. I text to her later to hear how the dive went.

Apparently the water is not as deep as we first thought and only came up to the divers' chests.

THURSDAY 28 DECEMBER 2006

Saddam Hussain is executed. Incontrovertible evidence that our *Peace Camp* has failed.

PREVIOUS PAGES
An illustration of the pond at Northlands Park by artist Zoe Griffiths for Andrea Mason's *Art U Need Needs U* diary.

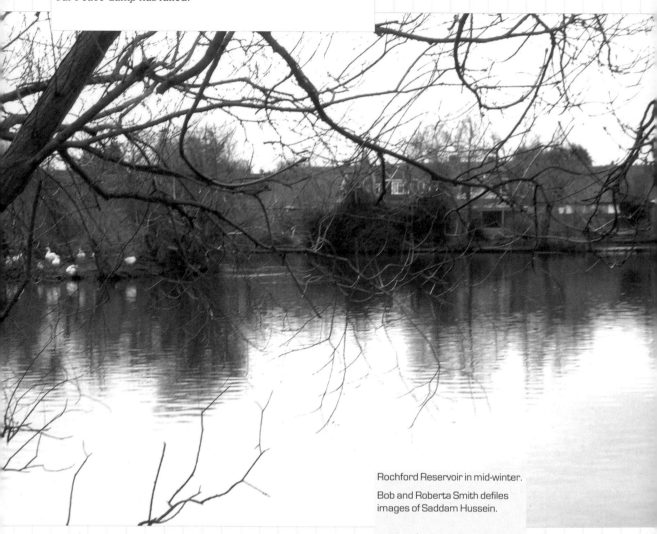

Rochford Reservoir in mid-winter.

Bob and Roberta Smith defiles images of Saddam Hussein.

He was in the bottom of a hole so

Troops could not believe their luck, report **Stephen Farrell** in al-Dawr and **Tim Reid** in Washington

Saddam had hidden in a man-size pit six to eight feet deep; he offered no resistance on being discovered despite being armed with a loaded pistol

and engineering units was on the ground under the cover of darkness, and had begun in close in on the farm complex. The soldiers were not told who their prey was, but knew that the target was highly prized.

The area consisted of two farmhouses, a field, a sheep den and a mud hut very close to the Tigris under which Saddam was ultimately found huddled in a tiny underground shaft.

At 6pm the strike force swooped, in helicopters tanks, Humvees and aircraft surrounding the small cluster of consolidated buildings and cordoning off the area. They raided the two farmhouses but they did not find Saddam. So they began an intensive search of the complex. After 25 min-

utes, one minute before Saddam's life as a fugitive was to end, the forces came to the mud hut, situated within a small, walled compound that also contained a metal lean-to.

Inside the walled compound the soldiers came across a spider hole entrance, camouflaged with bricks and dirt. After they brushed away the dirt they came across a hatch made of lightweight styrofoam and covered with a rug. At 8.26pm the troops pulled it open and could hardly believe their eyes.

Hiding in a narrow, man-sized pit, six to eight feet deep and offering no resistance, was a bedraggled and heavily bearded Saddam — literally the one who confronts. Despite being armed

with a loaded pistol, he offered no resistance.

"As he came up he was very much bewildered," Major-General Ray Odierno, the 4th Infantry Division commander said. "There was no resistance to it sort. He was in the bottom of a hole, so there was no way he could fight back. He was just caught like a rat."

Later Pentagon officials said that Saddam had acknowledged his identity as he was pulled out of the hole.

His hiding place was supplied with a crude ventilation, pipe and an exhaust fan that protruded above the ground.

The squalid hideaway had probably been built since April, General Odierno said. "My guess would be that he

has 20 or 30 of these all around the country that he moved around," he said.

General Odierno said that he believed that Saddam had crawled into the hole when he heard the troops coming. The farmhouse complex was cluttered with clothes, he said. Some were old, but there were some new T-shirts, shirts and socks, some still in their wrappers and some sandals. In another small room was one chair, a bed, and "clothes strewn all over the place" he added.

The soldiers who had dragged him out were extremely happy and extremely excited, he said.

As part of a rough and ready underground complex, the troops found a rudimentary

kitchen, supplied by water from the Tigris.

From Saddam's hiding place, General Odierno said: "You just about saw some of these palace complexes. I think it rather ironic that he was in a hole in the ground across the river from these great palaces that he's built, where he robbed all the money from the Iraqi people."

Two men living with Saddam, who have not been identified, tried to flee the scene as the troops arrived but both were captured immediately.

At 9.15pm with Saddam already on a helicopter heading south to Baghdad, a further search of the complex uncovered two AK-47 rifles.

Continued on facing page

In good shape even after so long in hiding

military commanders coveted the outright humiliation of Saddam Hussein by broadcasting television cameras of fitness the rudimentary medical examination performed on the former dictator.

This fatigue that pronounced a binge of death and rigor was fast, but by no wire, under his spider hole entrance, that it was by no wire, under his spider hole...

Once Saddam had been shaved of his tangled beard and had his hair dyed, he seemed to look very much as he had before the Iraq conflict; there was no great loss of weight or obvious signs of ill-health. Possible he was slightly dazed or confused but in true circumstances, this would be normal and there was no other evidence of psychological distress.

Usually only signs of severe or advanced disease are detected by the routine, examination-room examination — some simple but standard tests as taking blood pressure urine analysis, listening to the heart and lungs and feeling the abdomen remain an important part of any health assess-

than the initial pictures of a routine throat examination would indicate.

Saddam appeared to draw the doctor's attention to his face. But this was presumably a response to the medic peering into his mouth as he took cells from Saddam's buccal mucosa for a routine DNA test, rather than because he had jaw or tooth pain.

ment, but before doctors can press with authority they would need to have the results of supporting X-rays and special cardiological tests. Likewise, Saddam will need to have complete blood tests so that the effects of his months in hiding, with inevitably a re-

stricted diet and probably too little exposure to the sun, can be determined.

Although it is unlikely that Saddam has been confined to his spider hole for long, he must have suffered enforced inactivity. In someone who has always tended to be over

weight, this could literally be feet lipid levels, raised and low calcium could raise tendency to heart disease.

It would be no surprise to question Saddam thoroughly and carefully as soon as possible that he man in a

person to his life on the run over the past few months.

Even the toughest people who have survived a stressful period sometimes react by showing signs of acute stress disorder or dissociative amnesia and become very poor witnesses for a time.

FRIDAY 5 JANUARY 2007

Meet at Southend Library for an update on Mili's Queensway Estate project with her steering group. Her project has developed into a subtle sculptural intervention, which will be beautiful and locate The Queensway Estate as a focal point among the typical English seaside illuminations of Southend. She has proposed to put a series of coloured Perspex shapes into the laundry rooms that will be seen only by the public when the lights in the rooms are turned on at night. The residents will see Southend coloured in different ways from the different blocks.

The meeting is rather frustrating. South Essex Homes, who are the managing agents of the block, are cautious about every detail of Mili's rather simple, straightforward presentation. I begin to wonder if this project will get through the pointless bureaucracy before the deadlines. One extremely clever aspect of Mili's project, is that for it to work, the infrastructure of the building—the lights and notice boards—have to be in place and working. In this respect Mili's project will ensure South Essex Homes and the council have to pay more attention to the block.

Residents of the Queensway Estate.

View of the Queensway Estate from below.

SUNDAY 7 JANUARY 2007

Trip to Canvey.

Second meeting of The Rendezvous Club. This time, Lucy has suggested we all discuss 'private property'. We go on an extraordinary tour of a gated community adjacent to Canvey Heights where the residents have carefully manicured lawns.

We stand in awe of seried rows of gnomes, china dogs and crocodiles with faux bronze children riding them. There are fountains. It's amazing. We discuss the nature of private property.

I am concerned to hear that Lucy's proposed plaques have run aground in the planning process. There is so much goodwill surrounding Lucy's project I imagine the planners will be pretty unpopular if they screw things up.

MONDAY 8 JANUARY 2007

I look in Andrea Mason's diary, and note she has declared today a "Walk to School Day" in the Northlands Park Estate. It's pouring with rain in Leytonstone.

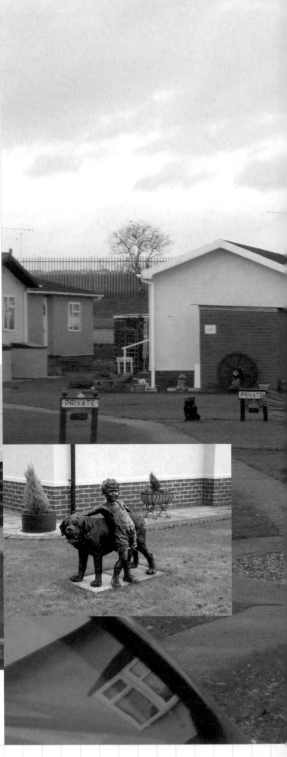

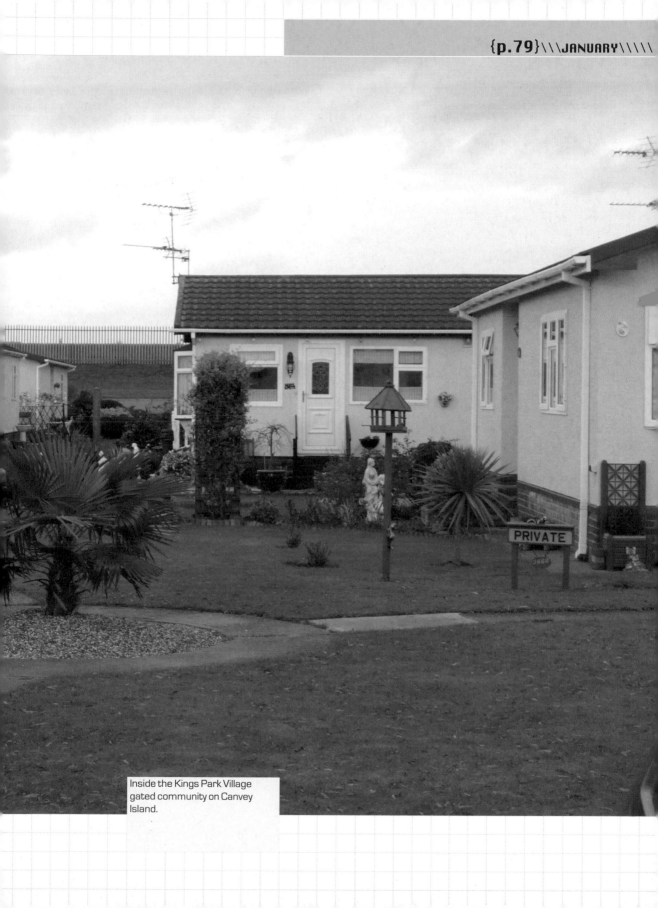

Inside the Kings Park Village gated community on Canvey Island.

THURSDAY 11 JANUARY 2007

Meet at the offices of the *Basildon Echo* to give a press briefing. I have made a placard out of wood that reads: "Women are Better Artists than Men" for a photo shoot. I have difficulty locating the *Basildon Echo* and park in a multi-storey car park in town, resolving to find the newspaper on foot. I grab the placard and make my way down the six floors to ground level. No sign of the *Echo* offices. After 15 minutes wandering around I have informed the shoppers of Basildon of my views on women artists. Eventually, I locate the *Echo* on a dismal industrial estate on the outskirts of Basildon. There is a real gale blowing at this point, and the "Women Artists" placard nearly garrottes me, as it is caught in a gust of wind that simultaneously sends my hat flying.

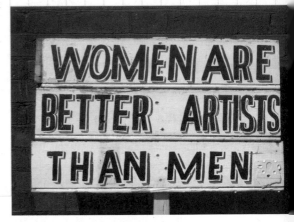

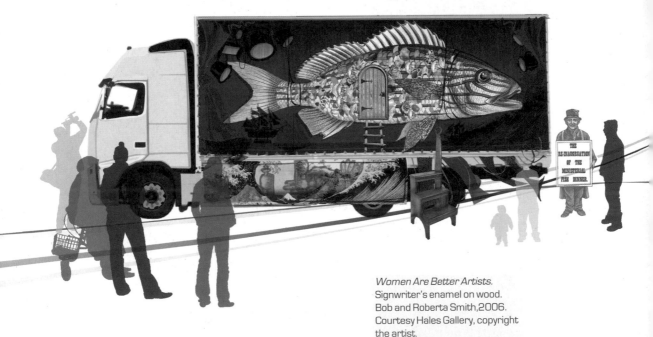

Women Are Better Artists. Signwriter's enamel on wood. Bob and Roberta Smith, 2006. Courtesy Hales Gallery, copyright the artist.

An initial design for Jane Wilbraham's idea of "The Moveable Feast", 2006. Courtesy Hales Gallery, copyright the artist.

OPPOSITE

Andrea Mason's *Art U Need Needs U* diary.

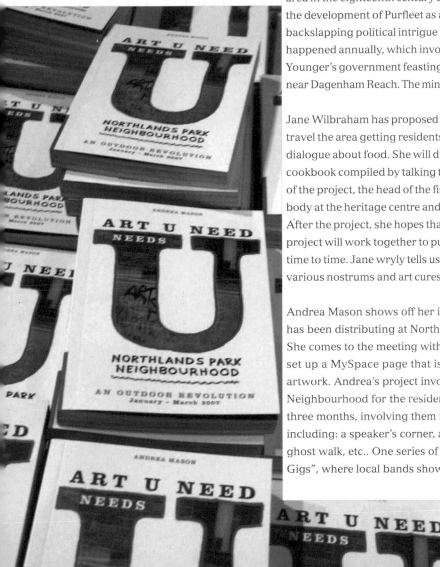

In the meeting everyone tells the *Echo* journalist what their project is about and how it is going. Jane Wilbraham tells us about her giant fish sculpture. The project is provisionally called *The Moveable Feast*. She has taken the history of the area in the eighteenth century as her inspiration, specifically the development of Purfleet as a gunpowder store and the backslapping political intrigue surrounding an event that happened annually, which involved ministers from Pitt the Younger's government feasting out of sight of "the populace" near Dagenham Reach. The ministers would dine on whitebait.

Jane Wilbraham has proposed building a huge fish that will travel the area getting residents and children involved in a dialogue about food. She will distribute a "Food Memories" cookbook compiled by talking to the local people. At the end of the project, the head of the fish will live at the school, the body at the heritage centre and the tail at the housing office. After the project, she hopes that the three partners in the project will work together to put the fish back together from time to time. Jane wryly tells us that within the fish will be various nostrums and art cures for social ills.

Andrea Mason shows off her impressive diary, which she has been distributing at Northlands Park Neighbourhood. She comes to the meeting with the revelation that she has set up a MySpace page that is an inherent part of the artwork. Andrea's project involves being at Northlands Park Neighbourhood for the residents every weekend for nearly three months, involving them in a huge array of activities including: a speaker's corner, a dog show, a poetry slam, ghost walk, etc.. One series of events are the "Guerrilla Gigs", where local bands show up and play.

Andrea has created a network of bands using a Northlands
Park Art U Need site on MySpace. She says a quite brilliant
thing; which is, for each of her events, "all you need is a body
and an idea". Her approach is direct and simple. There is no
attempt to complicate things. Andrea has already involved
people in the speaker's corner and her ramble around the
estate was given a kind of surreal edge by a crazy bell ringer
who wouldn't be quiet.

The journalist is enthusiastic about everything and says,
"This sort of thing is perfect for the 'Leisure Section'."

FRIDAY 12 JANUARY 2007

Jo asks me to invent a slogan for the project for an ad in
another art journal. With Dr Feelgood in mind, I tell her,
"The Thames ain't no Mississippi and Public Art ain't the
Delta Blues". This becomes: "The Thames is the new
Mississippi and Public Art is the new Delta Blues."

Mmmmmmmmmmmm… is London the new New Orleans?

SATURDAY 13 JANUARY 2007

Fantastic interview on Radio 2 with the surviving members of
Dr Feelgood. I text Lucy to see if she is listening to it. She says
she has known about it for months. She tells me to get their
Down by the Jetty LP.

I receive a vociferous e-mail forwarded from Commissions
East about the Northlands Park Project. The e-mailer complains
about the "waste of public money" and inappropriateness
of Andrea Mason's project, which is aimed at old people
but focuses largely on disaffected youth. There are some
reasonable points made but also some wilful misunderstandings
and the whole tone of the e-mail is quite insulting. I wonder if
Andrea has seen this and how she is reacting. I write a reply,
but in the end David Wright frames the official response.

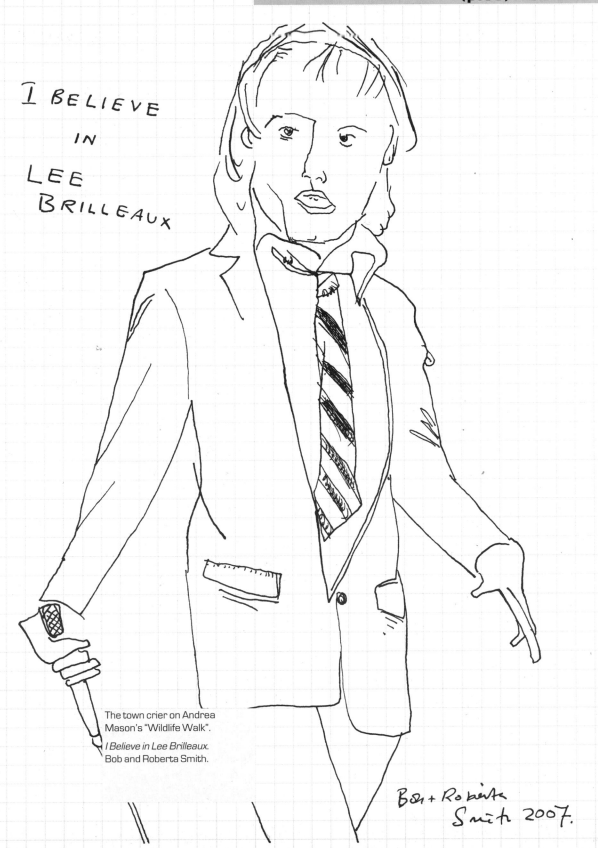

I BELIEVE IN LEE BRILLEAUX

The town crier on Andrea Mason's "Wildlife Walk".

I Believe in Lee Brilleaux.
Bob and Roberta Smith.

Bob + Roberta Smith 2007.

THURSDAY 18 JANUARY 2007

It's warm, wet and very windy. I travel by train to Rochford
to witness Hayley Newman throw the parts of her sculpture
that have been designed by youth groups into the reservoir
at Rochford.

She has a group of divers to do the job. They weigh the
elements of her *Secret Sculpture* down with horseshoes.
The divers are decked out in full diving kits. The knowledge
that the reservoir is barely four feet deep takes away from
the drama somewhat, yet the appaling weather conditions,
which have by noon deteriorated so much so that fences are
being ripped up and tiles are being whisked off roofs—piles
the drama back on for us.

It's wonderful watching the divers throwing Hayley's work
in the water. The whole event reminds me of JMW Turner's
painting *Peace Burial at Sea* which hangs in Tate Britain—
the ferocious weather accompanied by the immersion of
'precious elements' into the depths. A solid crowd braves the
weather. A groovier, cooler reference occurs to me, this work
is an echo from the early 1970s. Mr Robert Smithson became

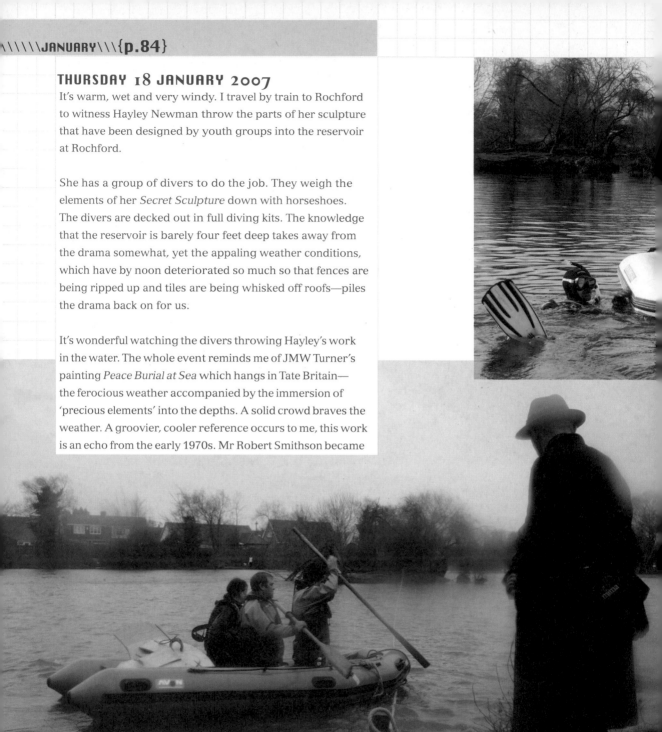

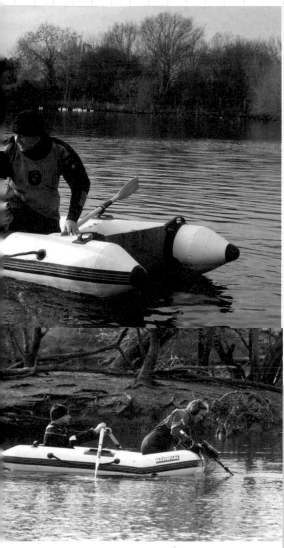

notorious for art actions where he would simply empty huge quantities of asphalt down embankments and bury buildings under rubble. Hayley's intervention here has the same kind of sculptural bluntness.

I get talking to a journalist from a local paper. He asks me, "Why art is important?" I say: "Without art we are just talking meat." He looks blank.

The publicist from Commissions East shows me the cuttings from the *Echo* newspaper. I am embarrassed that my plan about saying women are better artists than men worked so well. The journalist just concentrated on the fact that all of the artists were women. This headline grabbing, but ultimately irrelevant fact obscures discussion of the individual artists and their unique approaches. I regret that idea.

I travel back to London. On the news later is the sobering statistic that ten people have died as a result of today's storm.

I check my computer. There is an e-mail from Jane Wilbraham:

Subject: Re: 'The Purfleet One Float Carnival.....'

An Outdoor Revolution indeed! Whose bright idea was that??!! ITS'S BLOODY FEBRUARY!!!! I would like to propose a motion that we re-name it 'An Indoor (but possibly going outside sometimes in the Spring when the weather calms down a bit) Revolution'—it has taken me 4 1/2 grueling hours in total today to get to and from Purfleet, and even then I was nearly blown off my feet several times... it's a good job I'm near to the ground anyway! Ah well, the fish masks are looking good—bluebottles next week!

and also from Jane…

The Purfleet One Float Carnival (or, The Re-Inauguration of the Ministerial Fish Dinner)

Could you please ensure that the title of the project (above) is used at all times, rather than just 'the giant fish sculpture'.

Many thanks,
Jane Wilbraham

I realise I am guilty of calling Jane's project "the giant fish sculpture" to her face. I e-mail to apologise.

Hayley Newman immerses the elements of her *Secret Sculpture* in Rochford Reservoir.

SATURDAY 20 JANUARY 2007

In Andrea Mason's *Art U Need Needs U* diary it reads:
"'Wildlife Walk' at Nevendon Bushes: Who or what lives in
these bushes?"

I fear for Andrea Mason, as I know the writers of the e-mail
sent on 13 January live, if not *in* the bushes, certainly *close
by* the bushes.

SUNDAY 21 JANUARY 2007

I e-mail Andrea to see how the walk went.

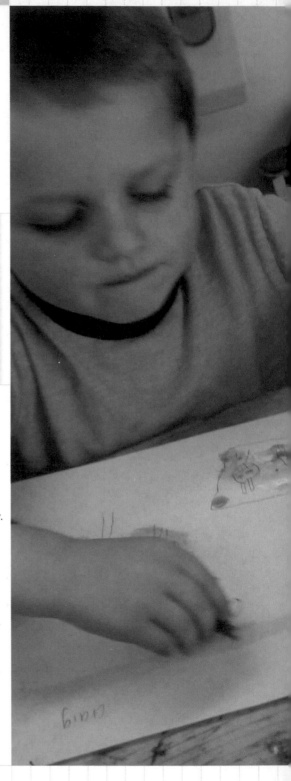

Subject: Re: 'Art U Need'

Hi Bob
Yes, we had a full house...woo hoo
About 22 of us, + some good drawings produced for
poster.

See you Saturday

Best
Andreax
P S I'm just loading up pics onto Blog + MySpace

My sister Roberta phones. She is elated. I didn't realise
her skills as a mental health nurse had propelled her so far
into management. For the last few months she had been
administrating her department, however, her skills in
controlling, rather than helping humanity, have now been
transferred to the world of a central government planning
department in charge of roads and bridges in the West Country.

After congratulating Roberta on her new job, we get to
talking about Isambard Kingdom Brunel. I say, "Those
Victorian engineers, they were the real public artists. They
weren't making huge structures out of iron because of
nostalgia for an industrial past, they were building the future.
They really knew how to express the indominatable human
need to control nature, to shape the landscape and traverse
the country with their railways and viaducts and bridges. I
love Brunel's Clifton Suspension Bridge in Bristol." Roberta
says: "All those Victorian bridges are coming to the end of
their useful lives. They will all have to go."

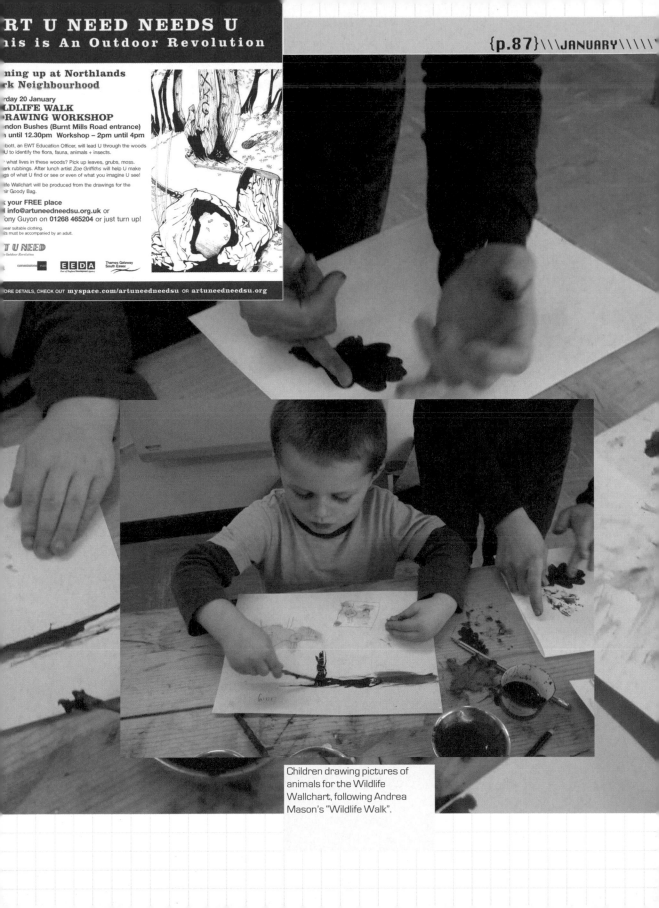

RT U NEED NEEDS U

his is An Outdoor Revolution

ning up at Northlands
rk Neighbourhood

rday 20 January
LDLIFE WALK
RAWING WORKSHOP
ndon Bushes (Burnt Mills Road entrance)
n until 12.30pm Workshop – 2pm until 4pm

bott, an EWT Education Officer, will lead U through the woods
U to identify the flora, fauna, animals + insects.

what lives in these woods? Pick up leaves, grubs, moss.
ark rubbings. After lunch artist *Zoe Griffiths* will help U make
gs of what U find or see or even of what you imagine U see!

life Wallchart will be produced from the drawings for the
ir Goody Bag.

k your FREE place
info@artuneedneedsu.org.uk or
ony Guyon on 01268 465204 or just turn up!

ear suitable clothing.
s must be accompanied by an adult.

T U NEED

EEDA
Thames Gateway
South Essex

ORE DETAILS, CHECK OUT **myspace.com/artuneedneedsu** OR **artuneedneedsu.org**

Children drawing pictures of
animals for the Wildlife
Wallchart, following Andrea
Mason's "Wildlife Walk".

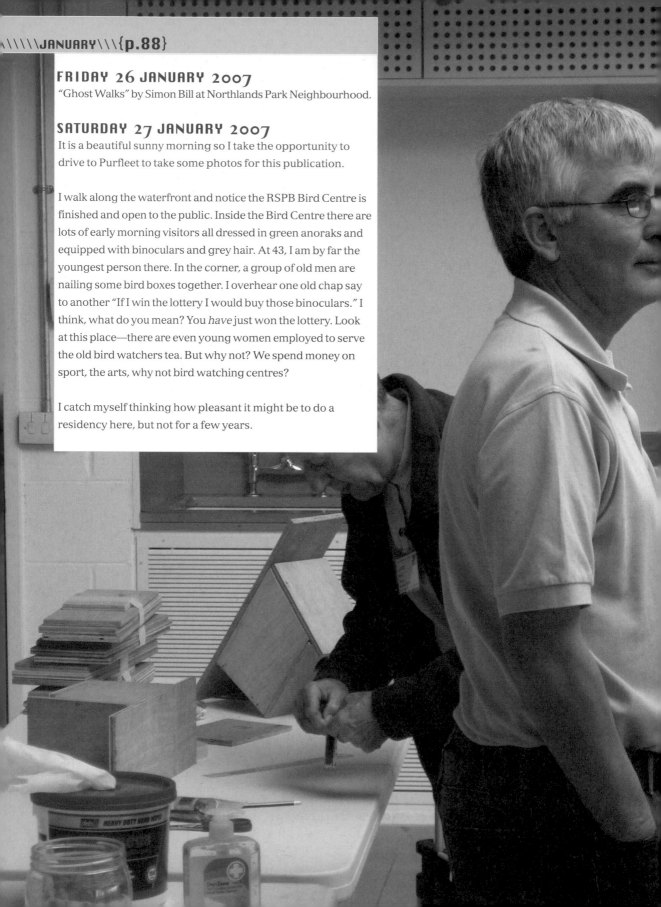

FRIDAY 26 JANUARY 2007

"Ghost Walks" by Simon Bill at Northlands Park Neighbourhood.

SATURDAY 27 JANUARY 2007

It is a beautiful sunny morning so I take the opportunity to drive to Purfleet to take some photos for this publication.

I walk along the waterfront and notice the RSPB Bird Centre is finished and open to the public. Inside the Bird Centre there are lots of early morning visitors all dressed in green anoraks and equipped with binoculars and grey hair. At 43, I am by far the youngest person there. In the corner, a group of old men are nailing some bird boxes together. I overhear one old chap say to another "If I win the lottery I would buy those binoculars." I think, what do you mean? You *have* just won the lottery. Look at this place—there are even young women employed to serve the old bird watchers tea. But why not? We spend money on sport, the arts, why not bird watching centres?

I catch myself thinking how pleasant it might be to do a residency here, but not for a few years.

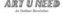

It's getting late so I belt down the A13 to Rochford to catch Hayley Newman hauling her *Secret Sculpture* from the deep of Rochford Reservoir. When I get there, the sculpture's secrets have been revealed, and on the bank sits a rather odd sculpture of two ducks involved in some sort of congress. Looking at the work, designed by kids, discarded by divers and then put back together by a group of old people, I wonder if actually what we have at the end isn't exactly the kind of public art I have been trying to get away from. Hayley looks a bit crestfallen that the sculpture has been so easily put back together. Robin Klassnik who shows Hayley's work at his Matt's Gallery in the East End is jubilant. When I say I can't imagine this sculpture making it into Hayley Newman's *catalogue résonne* he laughs and says, "No, it's wonderful. The whole thing from beginning to end must be considered. Hayley has used the whole story in her work."

Men build bird boxes at the RSPB bird sanctuary.

The sparkling new RSPB building.

Robin Klassnik is the architect of a particular kind of English conceptualism that is very positive about the artist's sensibility and need to never compromise. I take what he says seriously and he is right. If Hayley had engineered a more oblique result then that would have destroyed the work. There is a lot going on with *Art U Need* today so I make my farewells in order to get to Andrea Mason's event at Northlands Park. As I leave the reservoir, I catch the eye of the duck sculpture once more and I rather like it—really just because it is so endearing. It reminds me of *Aphrodite at the Water Hole* which Tony Hancock sculpts in his film *The Rebel*.

I miss the beginning of Andrea's "Misguided Tour" and wonder where in this vast estate the group would be. To the west of the estate is the rather attractively landscaped Northlands Park itself, in which sits a tea room where I know the group will finish their day. There is a golden pink light which makes everything look wonderful so I resolve to explore the park and take a few photos of the estate for this book. I take a few shots of some ducks on the lake, in which, in the background I can see the hides of a few fishermen. One of the fishermen shouts something at me, but as I am on the other side of the lake I can't make out what he is saying. I think nothing of it and make my way back to the tea room where I meet up with Andrea and a group of artists called Wrights and Sites who have orchestrated the "Misguided Tour".

Just as an earnest chap is telling me about how they split into four groups each walking in a different direction—north, south, east and west for one hour to see where they would end up, in burst two policemen. They beckon me to come outside with them and then proceed to question me about why I was taking photos on the estate. I am showing them my images of mallards, coots, and gulls flying low over the lake, when an angry woman in a tracksuit comes up to us and shouts, "That's him. He has been taking snaps of my kids." Now I am scared. This lady means business and there are a lot of equally threatening mums and dads loitering around a structure known as the Teenage Village. Jesus Christ, I think, I am going to need the police to get out of here in one piece. I want to show her the photos of the lake and tell her it's a pretty strange kind of porn—'hobbing a wonk' over a mallard duck.

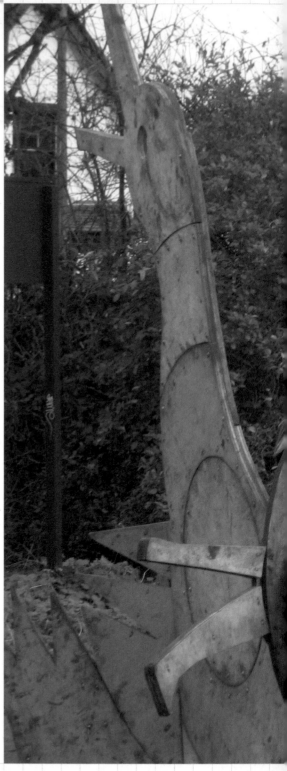

[Left to right] Kathryn Klassnik, Robin Klassnik and Hayley Newman with the assembled sculpture.

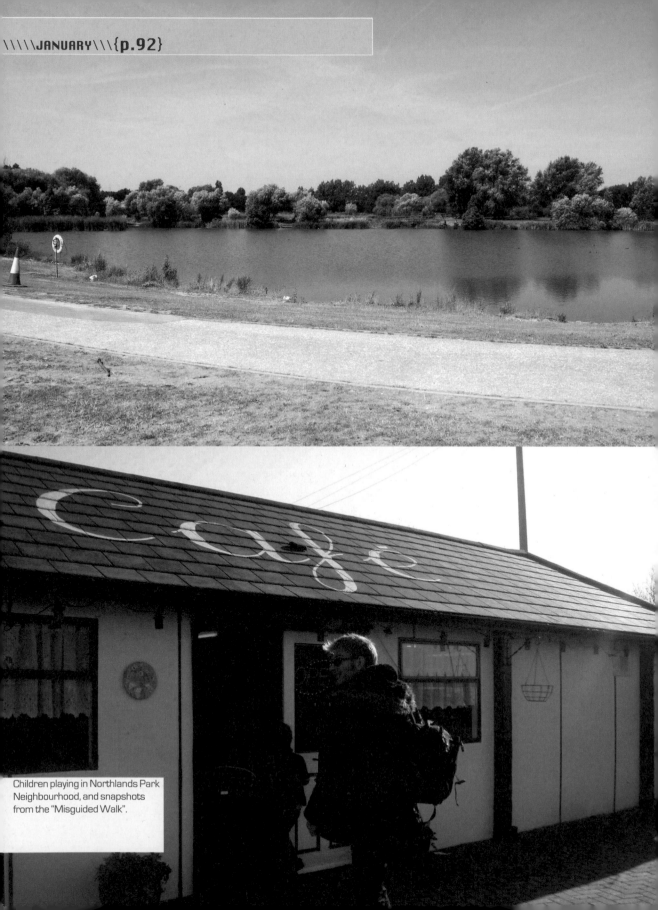

Children playing in Northlands Park Neighbourhood, and snapshots from the "Misguided Walk".

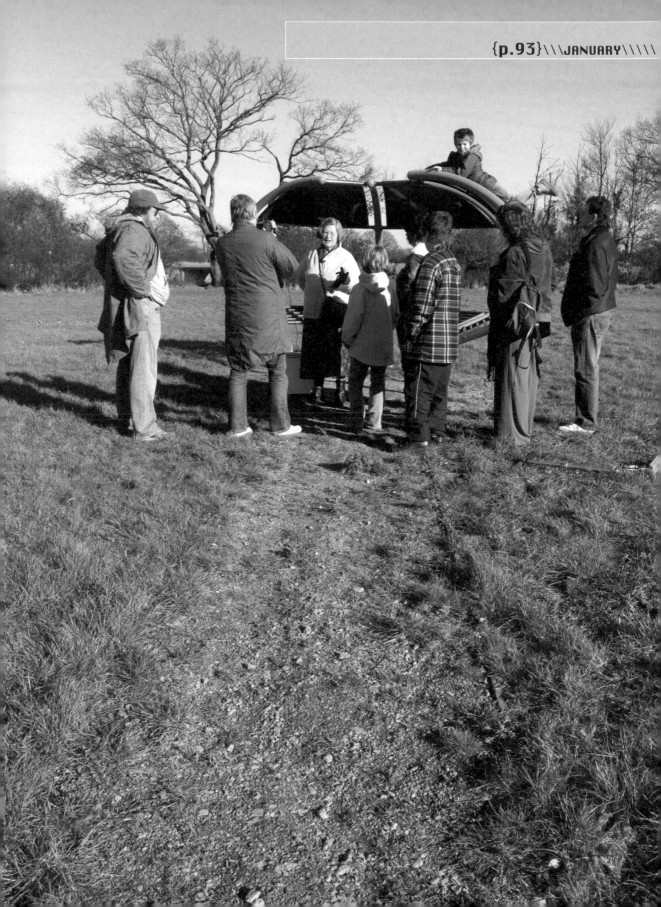

I have to tell the police about my position as a lead artist in the Arts Council hierarchy of 'do-gooding' artists that want to give people living in The Thames Gateway an experience of contemporary art. Sensibly, the two officers accept that I am not a pervert and disappear to fight real crime.

Putting together the angry e-mail and this experience, I realise that a lot of the people in Northlands Park Neighbourhood are suspicious of outsiders. I acknowledge they don't have to embrace our project, but equally I don't need to be accused of being a pervert just because I wear a trilby hat and look a bit different.

In this rather defensive frame of mind, I rejoin Andrea Mason and the Wrights and Sites group. I lighten up a bit after a cup of sweet tea, and Andrea tells me about the people she has met that have got involved in her project, and who seem really engaged with it. I am glad. I joke with her that even if we just reach one person, it will be worth it. We look at each other and there is an unspoken thought, which is: "Nobody said it would be easy."

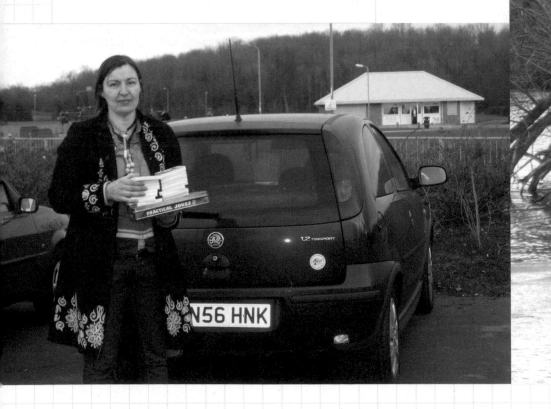

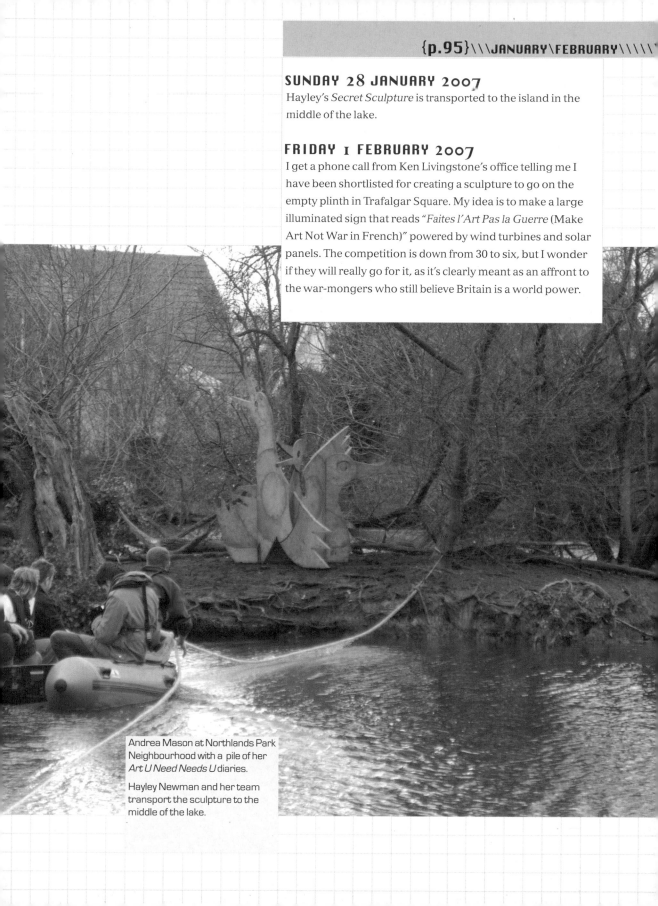

SUNDAY 28 JANUARY 2007

Hayley's *Secret Sculpture* is transported to the island in the middle of the lake.

FRIDAY 1 FEBRUARY 2007

I get a phone call from Ken Livingstone's office telling me I have been shortlisted for creating a sculpture to go on the empty plinth in Trafalgar Square. My idea is to make a large illuminated sign that reads "*Faites l'Art Pas la Guerre* (Make Art Not War in French)" powered by wind turbines and solar panels. The competition is down from 30 to six, but I wonder if they will really go for it, as it's clearly meant as an affront to the war-mongers who still believe Britain is a world power.

Andrea Mason at Northlands Park Neighbourhood with a pile of her *Art U Need Needs U* diaries.

Hayley Newman and her team transport the sculpture to the middle of the lake.

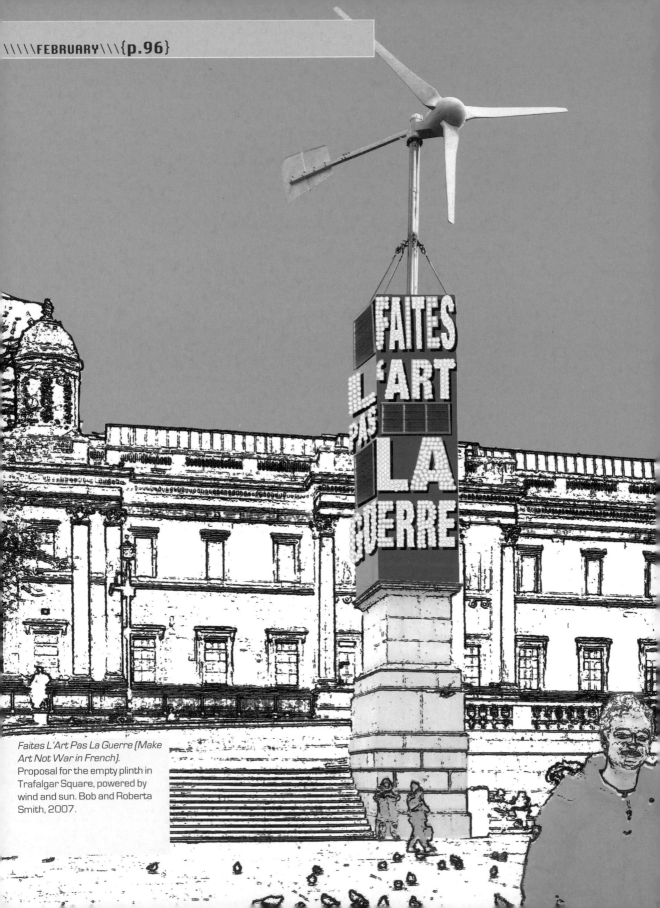

Faites L'Art Pas La Guerre (Make Art Not War in French). Proposal for the empty plinth in Trafalgar Square, powered by wind and sun. Bob and Roberta Smith, 2007.

SATURDAY 3 FEBRUARY 2007

Andrea Mason's "Speaker's Corner" event at Northlands Park
Neighbourhood. I decide to give the Northlands a swerve this
week. I feel guilty about not supporting Andrea, but from
the way Andrea was enthusing about the growing level of
participation, I am fairly confident there will be a reasonable
turnout. I think how remarkably well Andrea Mason's project
is working. She is creating an evolving social network rather
than an object—her *Art U Need Needs U* diary enters a
communal space, which an object could never occupy. Art
becomes a network of developing relationships, which
employs the principles of six degrees of separation, in
which everyone knows someone who knows someone.

Today is also my birthday. We throw a biggish party at the
Leytonstone Centre for Contemporary Art. It is not every day
you are 44. Hayley Newman comes to the party and brings me
a gift of a fisherman's float on which she has painted her
Secret Sculpture logo.

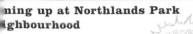

RT U NEED NEEDS U
is is An Outdoor Revolution

ning up at Northlands Park
ghbourhood

rday 3 February
EAKERS' CORNER Pt.2
nage Village Green off Tyefields
n until dusk

t something to say? Get another chance to
f your mouth off! No experience required.
turn up. AUDIENCE. Yes U. Come + listen,
, applaud or boo + continue the debate
ose around U.

hing you like as long as it's not obscene,
ous or incites a riot!

commissions EEDA East of England Development Agency | Thames Gateway South Essex | ART U NEED An Outdoor Revolution

ORE DETAILS, CHECK OUT myspace.com/artuneedneedsu OR artuneedneedsu.org

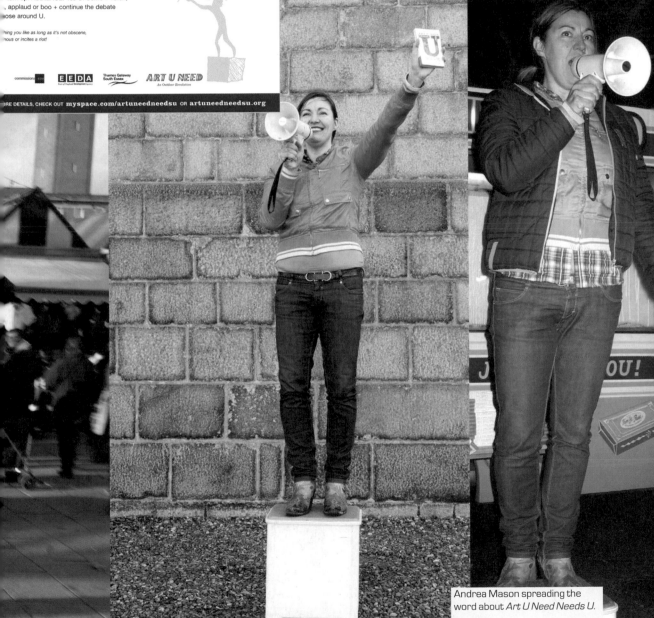

Andrea Mason spreading the word about *Art U Need Needs U*.

SUNDAY 4 FEBRUARY 2007

It is a beautiful, clear, cold day. Surprisingly, very surprisingly, considering the new mixtures of alcohol my stomach has had to digest overnight, I wake up with no hangover.

I try persuade Jessie and the kids to come with me to Canvey Island to walk Canvey Heights once more with Lucy Harrison, but there's no dragging the kids away from various play dates and the TV.

Wonderful Sunday lunch in The Monaco on the sea front at Canvey. Delicious roast beef. I sit opposite a man of around 70 who tells us a story about his son who was set upon by a group of Mods in the 1970s. The Mods broke his jaw and he ended up in hospital. The next week, when the Mods turned up again, the Rockers threw all their scooters in the Thames while they were in the pub. He said the Rockers were like the Mafia. They told the Mods if they came back they would be dead. Then he pauses and says: "That's what I like about Canvey. There is a real sense of community."

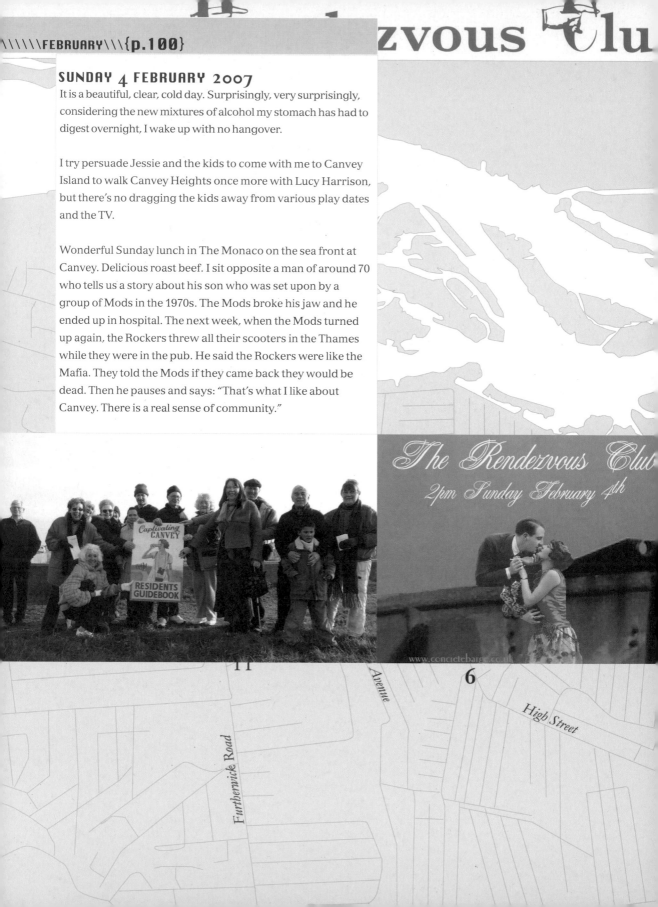

The Rendezvous Club
2pm Sunday February 4th

www.concretebarge.co.uk

Sunday 4th February

2 3
CANVEY
HEIGHTS
1

8

Museum

Residents of Canvey Island posing with Bob the Brush's *Captivating Canvey* sign.

An invitation to The Rendezvous Club's walk on the theme of 'rumour'.

On our walk around the heights I get talking to two renegade members of the Canvey Historical Society, who have a real passion for Canvey. We spend the afternoon talking about the Essex Delta Blues, Wilco Johnson, Elvis Costello's appearance on Canvey in 1978, Ian Dury and Southend connections with the Kursaal Fliers. We walk along the sea front. They point out the site of the Canvey monorail, which I don't know whether to believe or not, and the site where a large concrete barge was beached. Lucy tells me she will probably continue The Rendezvous Club after the official project is over. Everyone who is a Canvey resident has their photo taken with a sign Lucy has commissioned from Bob the Brush.

We finish our walk back at The Monaco. As I walk back to my car along the sea wall, I imagine what Canvey must have been like before the flood in the 1950s. From the Heights you can make out where a huge creek which once teamed with small boats and jetties, and a community of people living a life it is difficult to live now. Somehow, true Canvey Islanders live beyond the rules. I resolve to dig out my copy of Dr Feelgood's *On the Jetty* when I get home.

I look out over towards Southend. The mudflat has become an evening feeding ground for thousands of birds. I hear a curlew. It is a haunting sound that takes me back to my childhood wandering on the moors in North Yorkshire. It appears displaced to me, down south on the banks of the Thames but it makes me think of the desolation and beauty of life on the Estuary. I think of the early sequence in Charles Dickens' *Great Expectations*, when Pip discovers Magwitch in a creek and steals a pork pie for him. The reason that the Mississippi is the inspiration for the Delta Blues is the same reason that Dr Feelgood came from Canvey. The Estuary gives one permission to daydream—permission to watch the sun go down, to watch cargo barges pass by and to pick up driftwood.

Stillness and all human activity facing each other out.

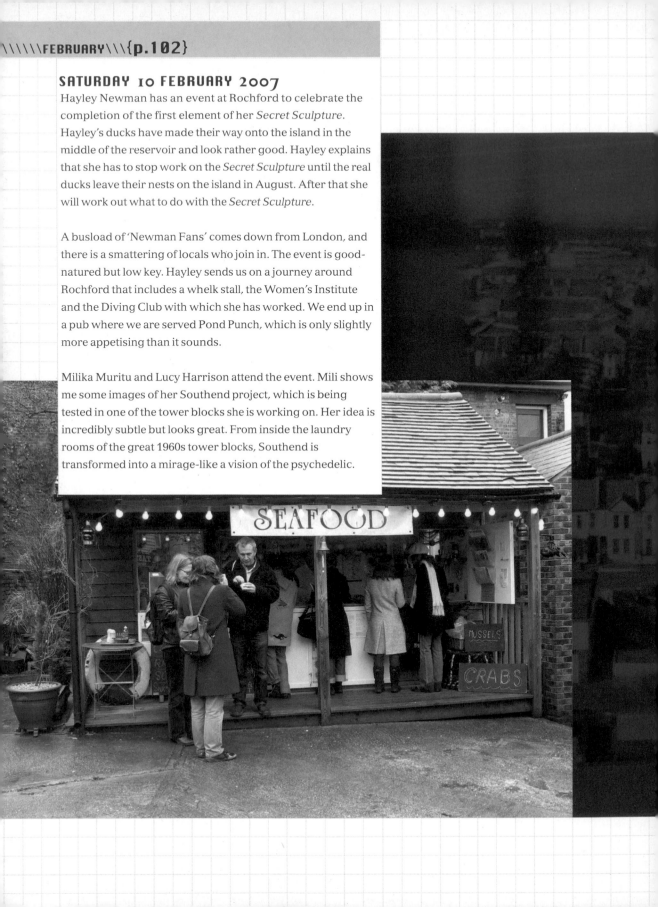

SATURDAY 10 FEBRUARY 2007

Hayley Newman has an event at Rochford to celebrate the completion of the first element of her *Secret Sculpture*. Hayley's ducks have made their way onto the island in the middle of the reservoir and look rather good. Hayley explains that she has to stop work on the *Secret Sculpture* until the real ducks leave their nests on the island in August. After that she will work out what to do with the *Secret Sculpture*.

A busload of 'Newman Fans' comes down from London, and there is a smattering of locals who join in. The event is good-natured but low key. Hayley sends us on a journey around Rochford that includes a whelk stall, the Women's Institute and the Diving Club with which she has worked. We end up in a pub where we are served Pond Punch, which is only slightly more appetising than it sounds.

Milika Muritu and Lucy Harrison attend the event. Mili shows me some images of her Southend project, which is being tested in one of the tower blocks she is working on. Her idea is incredibly subtle but looks great. From inside the laundry rooms of the great 1960s tower blocks, Southend is transformed into a mirage-like a vision of the psychedelic.

SUNDAY 11 FEBRUARY 2007

My wife, Jessie, has to go to New York for her father's 70th birthday party. Her dad is a twin. Her uncle has a new wife. The brothers are Jewish but the new wife is not. The new wife has devised a 'Western style' party. Jessie points out that the Wild West was America's Holocaust. Nevertheless, she is trying on a cowgirl shirt with a diamante sheriff's badge. I ask her: "You put a few sequins on the swastika and you think its okay?" She says: "Don't worry, I'm only a rhinestone Nazi."

Robin Klassnik enjoys a whelk at Hayley Newman's *Secret Sculpture* launch.

The view of Southend through Mili Muritu's *Queensway Streams* installation.

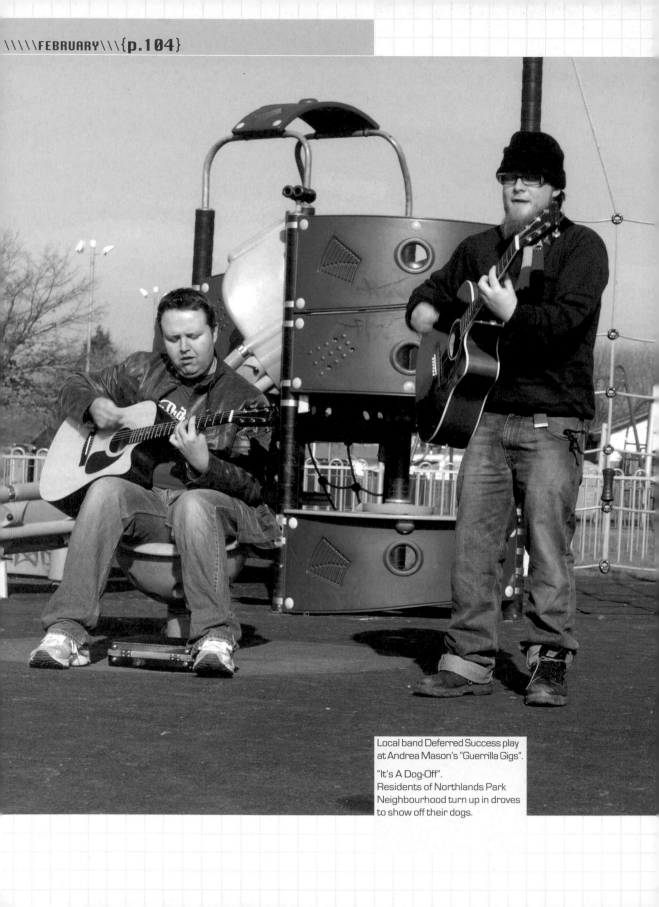

Local band Deferred Success play at Andrea Mason's "Guerrilla Gigs".

"It's A Dog-Off".
Residents of Northlands Park Neighbourhood turn up in droves to show off their dogs.

RT U NEED NEEDS U
his is An Outdoor Revolution

ming up at Northlands Park Neighbourhood

rday 17 February
ERILLA GIGS
t at Northlands Park Cafe, Noon
A MEMBER OF A BAND? Do U want to get your band heard?
ntact info@artuneedneedsu.org or just turn up + start playing.
ng: The Memory Band, Bootsale, Lixsy, Our Dielayted Affair,
rmilk, Deferred Success, Dirty Mac, Nick Silvey.

day 18 February
S A DOG-OFF!
ley Park (Rushley Rd. entrance) Noon
dog-owner or dog-lover? Want to show off your beloved pet? Meet us.
ark from Noon. Your pet will love it + there are prizes to be won.
t; don't forget the poop scoops; please take your litter home!

- Arcadia's **Pimp My Pup!** the best blinged-up dog wins!
- Andrea's **Dog-Obstacle Race**
- **Romance, Romance** presents **A Day at the Dogs**
- DJ Richie Don (from MTV's Pimp My Ride UK)
 presents his **Special Guest Category**

ASK THE EXPERTS Runwell Dog Training Club Q + A advice session,
alth, nutrition + training tips.

ART U NEED
An Outdoor Revolution

MORE DETAILS, CHECK OUT myspace.com/artuneedneedsu OR artuneedneedsu.org

SATURDAY 17 FEBRUARY 2007
"Guerrilla Gigs" day at Northlands Park Neighbourhood. AT A TEENAGE VILLAGE NEAR YOU!

SUNDAY 18 FEBRUARY 2007
"IT'S A DOG-OFF" at Northlands Park Neighbourhood.

I wake up in terror at the thought of packs of pitbull terriers ripping the faces of three year old toddlers. I talk to Cathy from Commissions East later in the day and she tells me rather smugly that her dog won the event. I think to myself: "What outrageous corruption."

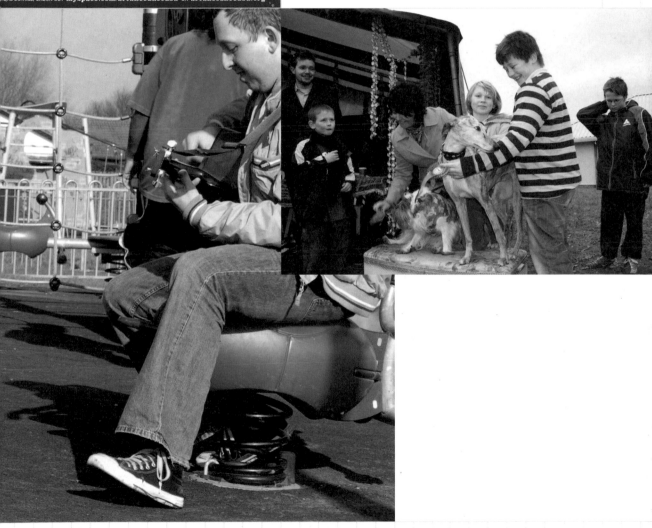

TUESDAY 20 FEBRUARY 2007

I have a radio show on Tuesday nights on Resonance 104.4
FM. Resonance itself is a fine example of artists and musicians
finding new ways to reach people. Over the next few weeks I
resolve to invite each of the *Art U Need* artists onto the show
to talk about their projects and play music that they would like
to take with them if they were marooned on the moon.

Milika Muritu is the first artist. Her choices of music mark a
fascinating insight into the era of suburban aspirational rock,
which we know as the New Romantic Era. Mili spent her
teenage years kicking around Southend listening to this stuff.
A lot of the music she plays is actually bands from Southend
that she knew 20 years ago. All the members of the bands she
plays have tousled, shoulder length, bleached blonde hair
and black eyeliner. The music reminds me of my art school
days in the early 1980s, when bands like Flock of Seagulls
and Blancmange attempted to raise the banner held aloft by
Spandau Ballet for another six months. Thankfully along
came The Smiths and The Fall, and the eyeliner was put back
in mum's make-up bag by everyone but Nick Cave fans.

Mili reminisces about the people she knew and the clubs she
hung out in. She is still in touch with a bass player from one of
the bands. He was the only other black person in Southend.
Now he teaches graphic design. She describes her project but
is guarded about the problematic aspects of it. After the show
she tells me the company who runs the housing estate for
the council is dragging its feet over the installation of her
work and that they clearly feel it's not their job to help. She
highlights a problem with the whole structure of the *Art U
Need* project which is: the funders want the project delivered
yesterday; the politicians, once they have decided to hand
over the money want outcomes almost immediately, yet the
middlemen (the council officials, the planners, and the other
gate-keepers of local government) are reluctant to move on
the agenda for the artists.

Andrew Jackson, Lucy Harrison
and Bob and Roberta Smith in the
Resonance FM studio.

Mili suggests that the middlemen should be made to tender for each of the projects so at least they would have some ownership and interest in realising the projects. I think this is a great idea, but given the time-scale we were given, I wonder how that might be achieved. All the projects would have benefited if the structures at the outset had had more time to be developed.

FRIDAY 23 FEBRUARY 2007

Meet Mimi from Home, a performance-based public arts group, about an event to be staged in May called *The Art of Protest*, which aims to get the public engaged with notions of political action through art. It is going to be a kind of outdoor festival.

Influenced by the e-mail about Andrea Mason's project I develop this proposal:

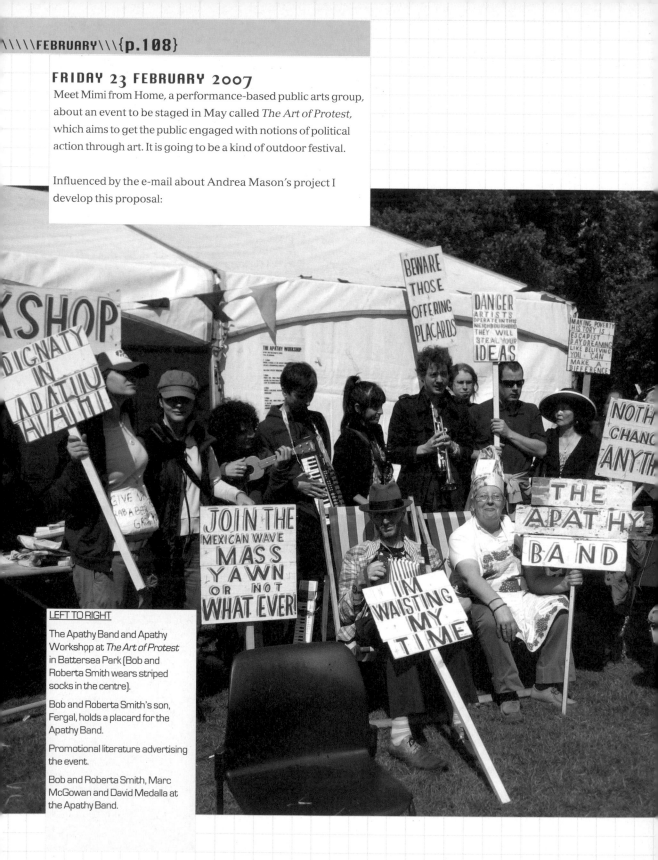

LEFT TO RIGHT

The Apathy Band and Apathy Workshop at *The Art of Protest* in Battersea Park (Bob and Roberta Smith wears striped socks in the centre).

Bob and Roberta Smith's son, Fergal, holds a placard for the Apathy Band.

Promotional literature advertising the event.

Bob and Roberta Smith, Marc McGowan and David Medalla at the Apathy Band.

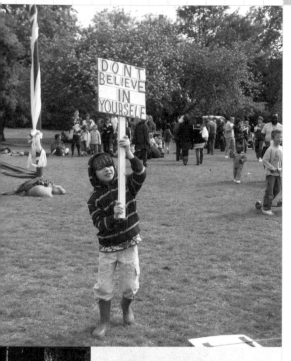

BOB AND ROBERTA SMITH'S APATHY WORKSHOP

The Apathy workshop invites hypocrites, the lazy sceptics, realists, apologists, popularists and unpopularists to devise prior engagements, heckles and excuses for not getting involved in the pointless attempts by the well meaning to Change The World.

The apathy workshop will offer a large badge with the legend:

MAKING POVERTY HISTORY IS JUST ESCAPIST DAYDREAMING JUST LIKE BELIEVING YOU CAN MAKE A DIFFERENCE

To anyone who pokes fun at the protesters: Tomato canes will be available for people to join together and attach the word 'fun' to.

The apathy workshop will offer a medium sized **"I'M GOING HOME"** badge to anyone who can come up with a really good heckle to shout at the motivated.

The apathy workshop will offer a small **"I CANT BE ARSED"** badge to anyone who yawns at someone who tries to get them involved.

During the Apathy Workshop there will be a **"DEMORALISE THE MOTIVATED DEVELOPMENT SESSION"** lead by Bob and Roberta Smith where we will all lie around the park assuming bored and uninterested positions.

More Sitting Around.

(end)

Bob & Roberta Smith's Apathy Workshop
Artist: Bob Smith

As a humorous and surreal antid[...] the prevailing spirit of the event, [...] Apathy Workshop invites hypocri[...] the lazy, sceptics, realists, apologists, popularists and unpopularists to devise prior engagements, heckles and excuses for not getting involved in the pointless attempts by the well-meaning to change the world.

MORE SITTING AROUND

Bob & Roberta Smith, courtesy of the artist

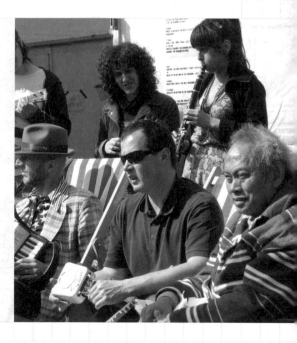

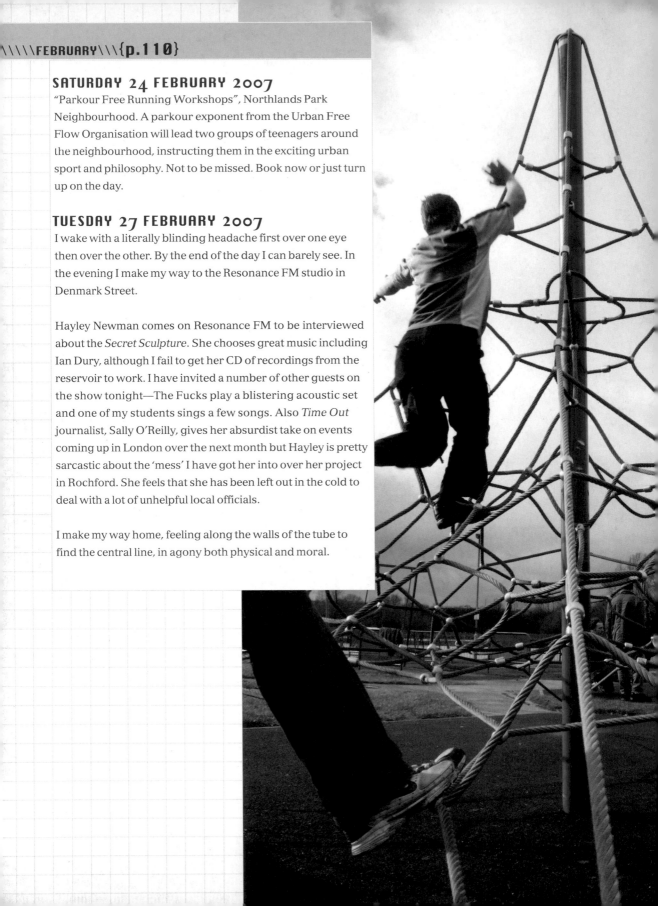

SATURDAY 24 FEBRUARY 2007

"Parkour Free Running Workshops", Northlands Park Neighbourhood. A parkour exponent from the Urban Free Flow Organisation will lead two groups of teenagers around the neighbourhood, instructing them in the exciting urban sport and philosophy. Not to be missed. Book now or just turn up on the day.

TUESDAY 27 FEBRUARY 2007

I wake with a literally blinding headache first over one eye then over the other. By the end of the day I can barely see. In the evening I make my way to the Resonance FM studio in Denmark Street.

Hayley Newman comes on Resonance FM to be interviewed about the *Secret Sculpture*. She chooses great music including Ian Dury, although I fail to get her CD of recordings from the reservoir to work. I have invited a number of other guests on the show tonight—The Fucks play a blistering acoustic set and one of my students sings a few songs. Also *Time Out* journalist, Sally O'Reilly, gives her absurdist take on events coming up in London over the next month but Hayley is pretty sarcastic about the 'mess' I have got her into over her project in Rochford. She feels that she has been left out in the cold to deal with a lot of unhelpful local officials.

I make my way home, feeling along the walls of the tube to find the central line, in agony both physical and moral.

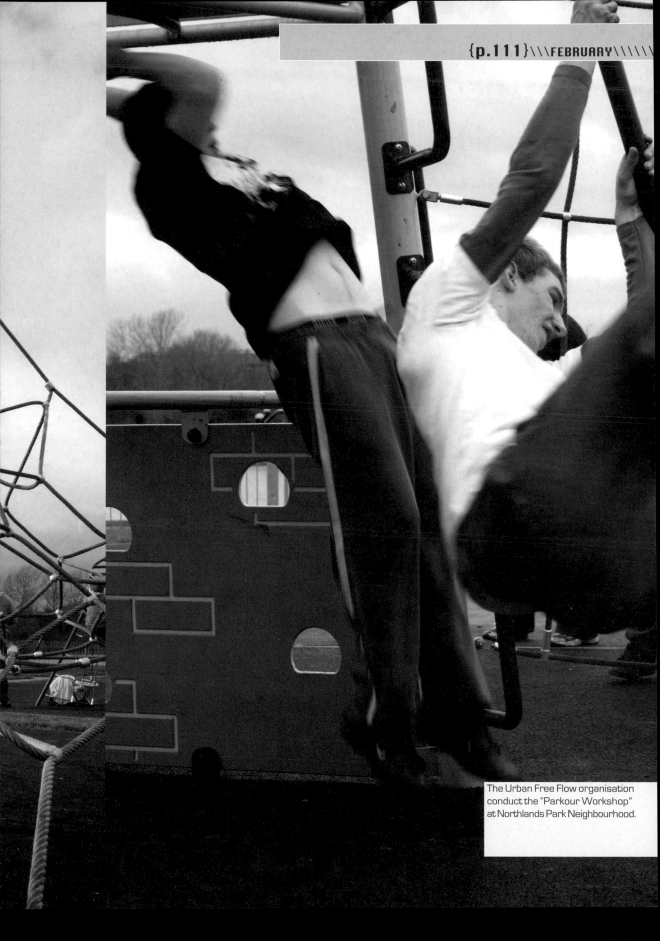

The Urban Free Flow organisation
conduct the "Parkour Workshop"
at Northlands Park Neighbourhood.

WEDNESDAY 28 FEBRUARY 2007

I get an emergency appointment to see a consultant in the eye
department at Whipps Cross Hospital. I am scared. I phone
the gallery where I show my paintings. I tell Paul Hedge,
the chap who runs the gallery, "I don't think I can paint my
paintings any longer." He laughs and says "Don't worry Bob;
we will get professional sign writers in to make your work.
They will probably do a much better job."

FRIDAY 2 MARCH 2007

Meeting with Commissions East and Black Dog Publishing to
discuss this book.

I am in a terrible state. They ask me why there is so much stuff
about China in the book. I tell them it's because it would be
impossible to do a project like ours over there. I can barely see
the people around the table and when it comes to discussing
the layout of the book, I give up, make my excuses and leave.

A professional Bob Smith could
offer a viable alternative should Bob
and Roberta lose his eyesight.

John 4:9.

SATURDAY 3 MARCH 2007

"Judgment Day" Northlands Park Neighbourhood.
I wonder if this blindness and pain is a judgment on me from
the aggressive e-mailer or perhaps all the artists have got
together and put a spell on me.

SUNDAY 4 MARCH 2007

I stay in bed. Although I can appreciate the implied melancholy
of the topics, I am afraid there is no way I can to get to Canvey
Island to the last of Lucy Harrison's walks to discuss 'Ceremony',
'Failed Projects', 'Lost Buildings', or 'Romance'.

TUESDAY 6 MARCH 2007

The NHS phone to arrange a date for an MRI scan. The
consultant suspects what ails me is a virus that will abate over
the next few weeks but wants to make sure there is nothing
worse, like some enormous undiscovered tumour, waiting to
engulf me. They have arranged for me to be scanned Friday
week, which also happens to be the press launch of *Art U
Need* at Tilbury Fort. I work out that if I rush from the hospital
to the station, I might just be able to make the launch event
where I am to give a speech. Rather foolishly I resolve to
interview Andrea Mason about her *Art U Need Needs U*
projects at Northlands Park Neighbourhood on Resonance FM.

Surprisingly the headaches seem to lift and the show goes
really well. Andrea is unfailingly positive about all her events
and the amount of people who got involved. She tells me
about Lisa, a resident at the estate, who wants to keep the
momentum going after the project has ended. Lisa's son won
a prize at the "Poetry Slam" event and she has been really
fascinated by the energy created by the *Art U Need Needs U*
projects. To my knowledge Andrea has had to deal with some
of the most disruptive e-mails from any of the groups *Art U
Need* has worked with, and for her to be so positive about the
project at this late stage is amazing. She seems rather exhausted
having spent every weekend since January organising events in
and around the estate, but her project has in many ways tried
to do the impossible in that it aims to engage everyone. It's a
bit of a dream to do that, especially on a council estate, but the
effort has paid off.

MONDAY 12 MARCH 2007

Rather coincidentally, Jane Wilbraham's eyesight has also
been plaguing her since working on *Art U Need*. I wonder if
there is a connection. I visit her specialist in Harley Street. He
reassures me there is no connection. What we both have is
quite different and not connected with the production of
public art.

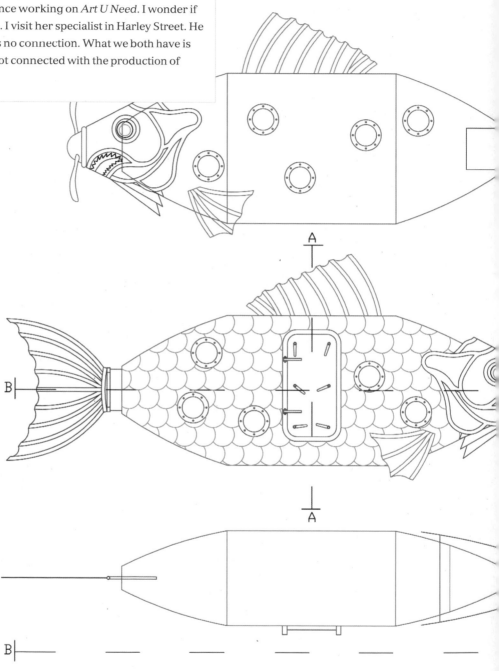

TUESDAY 13 MARCH 2007

I have arranged to talk to Jane Wilbraham on Resonance but
I am really not up to it. Thankfully Jessie, a seasoned art
performer, stands up to the mike for me and interviews Jane
about the *Purfleet One Float Carnival* (*not* "the giant fish
sculpture"). I listen to the show in the bath, which I think is
an entirely appropriate place to hear about an art project
centred around a large pre-fabricated fish.

Jessie has chosen fish-themed records to play, and together
with Jane's selection of her favourite discs, including
"Bondage Up Yours" by X-Ray Spex and "Lilly the Pink" by
The Scaffold, an enjoyable musical feast is unleashed upon
the Resonance listeners more used to the bleeps and squeaks
of late night avant-gardism. Jane tells us about the cook book
she has produced to accompany her project, which includes
recipes and instructions including how to fire a cabbage
using a seventeenth century cannon. Jessie and Jane produce
a radio show that would be quite at home on Radio 4, so replete
is it with amusing anecdotes and nuggets of interesting
historical fact. I can almost imagine Ned Sherrin taking over
to confirm an apocryphal tale concerning Noel Coward's
adventures in Purfleet.

scale
1:30

Jane Wilbraham's final plans for
The Purfleet One Float Carnival
[or, the Re-Inauguration of the
Ministerial Fish Dinner].

Diagram of the human eye,
showing impermeability to the
influence of public art. Modified by
Bob and Roberta Smith, 2007.

The Human Heart.

RETINA

MACULA

IRIS
PUPIL
CORNEA

LENS

OPTIC
NERVE

Bre. Smith.

FRIDAY 16 MARCH 2007

A rather strange and emotional day.

The MRI scan was enjoyable. The scanner makes a sound very like the brutal avant-garde rock trio Owada, led by Turner Prize winner Martin Creed. However, my joke that I wished he had chosen another CD to play to calm me down was lost on the MRI technician.

Jessie and I run from the hospital to meet friends and students of the artists to get the C2C train to Tilbury for the launch.

The launch is a strange affair. Commissions East have organised a press event equi-distant from all five locations to be able to launch all of the projects together. The idea was to try to avoid any of the artists becoming upset that their location wasn't chosen for the big press launch. Consequently there is no art to see, and no press to see it. Still there is a nice party for everyone involved, which is important, and some speeches.

I can't see very well, so Jessie writes out my speech with a large felt tip marker. I find the speech hard to get through. At one point I mention that during the process of the selection of the artists for the project, we realised all the artists were women. At first I thought this was because of some special qualities women had over men, ie. about being organised and useful. But then I realised that actually it was perhaps something more personal, in that the artists who have had the greatest influence on me have been women: Eve Hess, Jenny Holzer, the great female artist Gustav Metzger (laughs from audience) Barbara Kruger, Phyllida Barlow, Tracey Emin, Sarah Lucas and Jessica Voorsanger. Lastly, I listed two artists who I knew quite well whose work I still love who died of cancer well before their time, Lucia Norgueria and Liz Arnold (sobs from the audience).

I only just made it past that point in the speech to wind up by saying *Art U Need* has not been about male self-aggrandisement but about shaping and developing work that really operates well in the public realm.

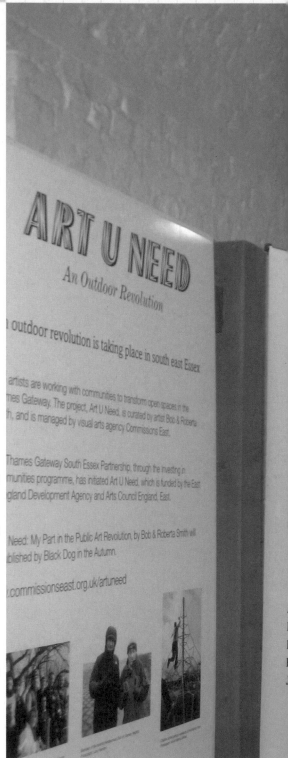

RT U NEED

An Outdoor Revolution

artists working
communities to
orm open spac
Thames Gatev

on Basildon
u Southend
on Canvey Island
nan Rochford
am Purfleet

Thames Gateway South Essex
Where people
come alive

Thames Gateway South Essex
Where people
come alive

Bob and Roberta Smith
addresses the people of Essex.

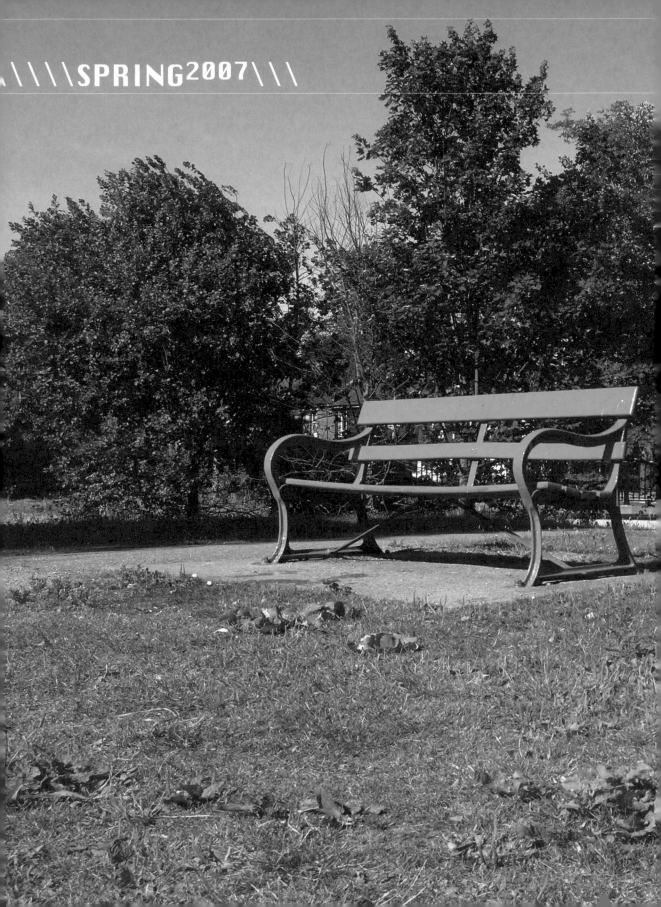

PREVIOUS PAGES
A bench at Rochford Reservoir.

TUESDAY 20 MARCH 2007

Thankfully it seems the viral diagnosis of my blindness is the correct one and today I can see and feel much better.

Lucy Harrison joins me on Resonance FM to talk about her project and the *Captivating Canvey* guidebook she has produced. She plays some wonderful music. We start the show with Dr Feelgood and she tells us about their manager, Chris Fenwick, who has contributed to the book and helped out by introducing her to various residents.

Lucy talks about the sights of Canvey, which include an oversized hedge and the place where a concrete barge was once marooned, but has now been removed. She has brought a wonderful CD called *Barge Sounds*, which contains poetry and field recordings made in and around Canvey.

Lucy tells us about Margaret Payne, a retired primary school teacher who collects historical information, and who Lucy has befriended. They go to musicals together. The whole feel of Lucy's project is very different from the other projects in that the people of Canvey Island have taken Lucy to their hearts and really helped her achieve what she wanted to do. She has had difficulties with the planning department which curtailed her desire to locate Bob the Brush's signs on Canvey Heights, but everything about the project feels good-natured.

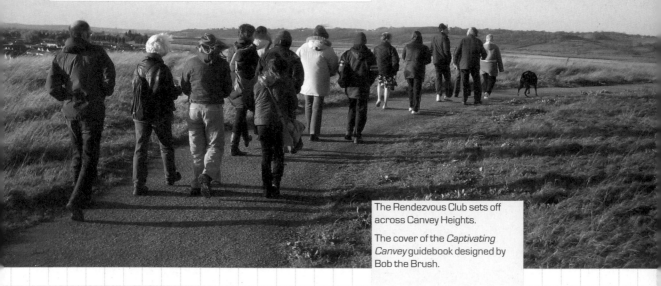

The Rendezvous Club sets off across Canvey Heights.

The cover of the *Captivating Canvey* guidebook designed by Bob the Brush.

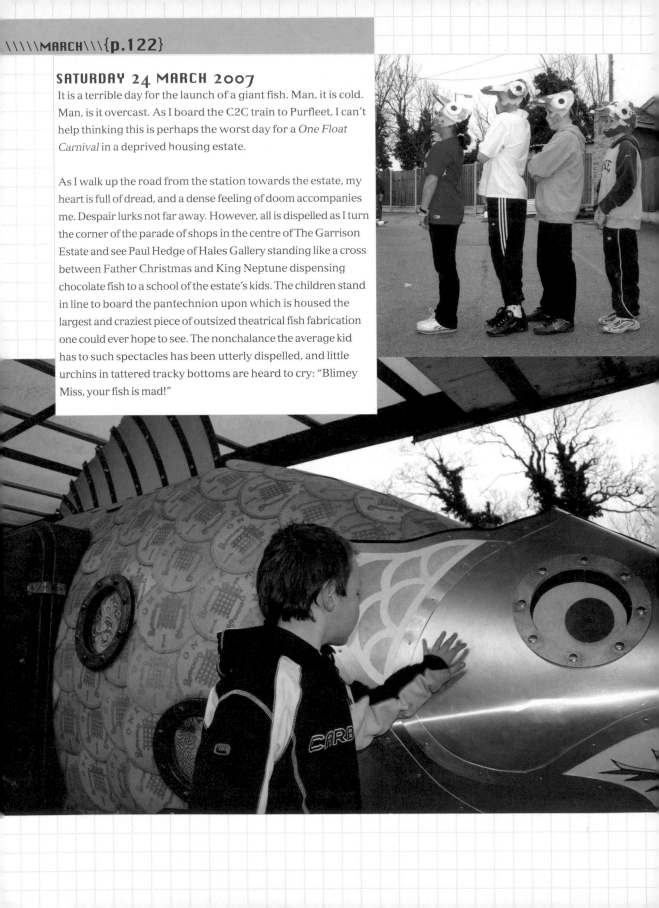

SATURDAY 24 MARCH 2007

It is a terrible day for the launch of a giant fish. Man, it is cold. Man, is it overcast. As I board the C2C train to Purfleet, I can't help thinking this is perhaps the worst day for a *One Float Carnival* in a deprived housing estate.

As I walk up the road from the station towards the estate, my heart is full of dread, and a dense feeling of doom accompanies me. Despair lurks not far away. However, all is dispelled as I turn the corner of the parade of shops in the centre of The Garrison Estate and see Paul Hedge of Hales Gallery standing like a cross between Father Christmas and King Neptune dispensing chocolate fish to a school of the estate's kids. The children stand in line to board the pantechnion upon which is housed the largest and craziest piece of outsized theatrical fish fabrication one could ever hope to see. The nonchalance the average kid has to such spectacles has been utterly dispelled, and little urchins in tattered tracky bottoms are heard to cry: "Blimey Miss, your fish is mad!"

Aboard the fish, Jane Wilbraham dispenses cook books to the kids. The driver of the pantechnion parps his horn and the *One Float Carnival* proceeds onwards to the Heritage Centre. At the Heritage Centre we are met by Gary. Gary volunteers at the Centre which in itself has an amazing collection of Purfleet memorabilia, folk art, militaria and dusty cases full of completely wonderful collections of International Rescue toys and T Rex Fan Club magazines. In one case is a tin model of a zeppelin, which looks very like Jane's fish sculpture. It even has a propeller for a nose. Followed by a gang of over-excited kids, the fish makes its way to its last stop—the Church Hall.

There the Church Warden, Demus, has laid out a grand spread of cakes and tea. It seems obvious that the church might be interested in the production of a huge icon from one of their top stories, but the images of fish that appear around the church comically seem like branding for Jane Wilbraham's project. The magnificent sculpture becomes an unwitting icon for the everyman.

The children of Purfleet dressed as whitebait to guard the fish.

Kids climb on board the float to inspect Jane Wilbraham's giant fish at *The Purfleet One Float Carnival (or, the Re-Inauguration of the Ministerial Fish Dinner)*.

FRIDAY 30 MARCH 2007

Artists in the Essex area are invited to a seminar on *Art U Need* at Rochford. All the artists are there to be questioned about their work but also to lead a discussion about what public art should be. I kick off the event, but soon everyone is talking about the possibilities for developing new ways of working. At the end of the day I write a manifesto cobbling together everyone's ideas.

A Manifesto for the Public Realm
Produced at the Art U Need Artist Seminar
Rochford, Essex 30 March 2007

'The manifesto will be inclusive of all buzz words and spin. All boxes will be ticked. All recipients' views will be listened to and evaluated.'

Working in the Public Realm

Artists will make small and large transformations to communities.

There are many opportunities out there for the artist to explore which require no funding whatsoever. Artists must intervene in the public realm wherever and whenever they can.

Self initiated projects provide autonomy for the artist.

Break into the institutions and museums of this land and tell them you are there.

Love the space between the Public and the Artist.

Celebrate indifference! Embrace the unusual forms of art. Art will dissipate boredom and forgetfulness.

Getting people involved can be positive even when the artist's project isn't what they expected. Rely less on outcomes; measure the process not just the product.

Creativity (non-social, non-educational) is an integral part of regeneration.

How can we read the Leviathan that is the public? We know what this public looks like but what language doth it spake?

After World War II the notion of the public was valued. Now everything is private. The public artist will reverse this trend.

Is there a place for Art for Art's Sake in public art?

On Being Commissioned

Artists should be put at the top of the process.

Artists will not be go-betweens.

Public art is not necessarily publicly funded. Support can be found in other sectors

Support the artist's relationship with funders and in particular their autonomy.

Emphasise that artists are not a quick fix political tool either for community or regeneration issues. Art is not a sticking plaster for social ills.

Communication is the key. Arrange mixed seminars with local government, potential commissioners, funders and artists.

Artist as facilitator? A justification of art via education; art becomes subservient to the community.

We must use the skills of the many and not just promote the grandiose careers of the few.

Art will be the ultimate tool of social engineering in the regeneration process. Dreams will be tempered by reality.

Taking risks is harder with a small budget.

What agenda? Objects or projects? Who do you please? When does collaboration become compromise? You choose!

The Artists' Perspective

We Are The Profession! Consult us. Don't tell us!

All art will be relevant to all areas. The process of engagement will allow for artistic freedom. The artist will create the framework and control the network.

Artists come to the public with an open mind and a clean slate.

The artist will have a personality.

Artists must eschew nostalgia.

There was nothing wrong with Barbara Hepworth!

Art will be informed by what we can't do.

The art world must at long last value the endeavours of the public artist.

The manifesto, as published by Commissions East.

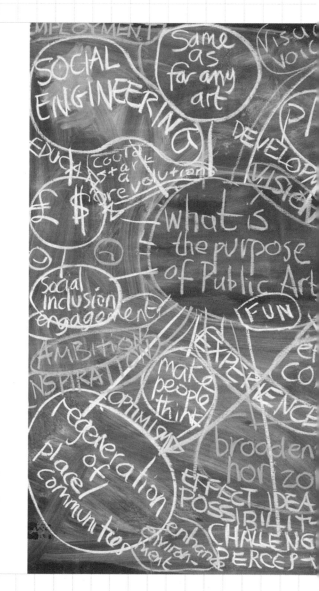

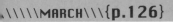

SATURDAY 31 MARCH 2007

Today is Canvey's day.

All the contributors to Lucy Harrison's project take people for walks around the island showing them exactly where they grew up and what has changed over the years. I go with Margaret Payne to see her grandmother's bungalow.

If you look carefully as you walk down the streets of Canvey, it has or had its own very unique style of architecture of 'roughcast timber buildings'. These buildings are constructed with a wooden frame and have sheet ply on the outer surface with plaster and lathe inner walls. They are typically one storey, and are fronted by a verandah, which has since been filled in to create a very narrow room for storing plant pots and other bits and bobs. Margaret's grandmother's bungalow is one such building. It is located not far from the sea wall, and was completely flooded in the Great Flood of 1953. Discussion revolves around the flood.

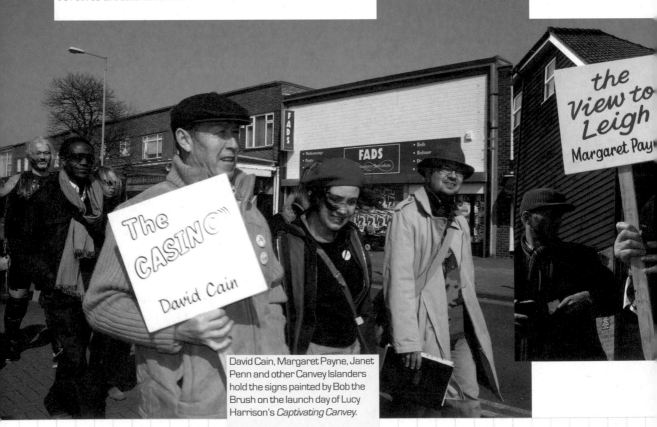

David Cain, Margaret Payne, Janet Penn and other Canvey Islanders hold the signs painted by Bob the Brush on the launch day of Lucy Harrison's *Captivating Canvey*.

Chris Fenwick tells us he was a "Flood Baby". He says after the flood everyone who had heard about the disaster sent provisions to the area. Britain was still under rationing, so in a way they benefited from the reconstruction. A sobering fact of the flood in Canvey was that very few people drowned— rather, they died of hyperthermia waiting to be rescued.

All tours meet again at the bus station for an open-topped bus ride to Canvey Heights on a beautiful vintage bus. Everything centres on the past in some way. Normally we think about art trying to shape the future, but Lucy Harrison is all about how our knowledge of the past is held in a fugitive state, waiting to be used by those who need us to forget. It is telling that had I taken another of the walks around Canvey my understanding of it and what I have just written would be different.

Another ride on the bus and we are at the Canvey Club, where Dr Feelgood used to play before they got big. It's a big party in a typical Canvey building with locals all greeting each other like long lost explorers. In 1953, the population of Canvey was 4,000. Today it is 48,000, so for a certain generation, meeting again is like seeing an old friend in a crowd.

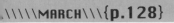

David and Jo take me to the "It's a Wrap" party at Basildon Theatre where Andrea Mason is holding the last event of her Northlands Park project. It is very moving as Lisa's son reads the poem he wrote for the "Slam Poetry" day. The poem is about bullying and it is clear that the lad has been bullied at school.

Get home at 10:30 PM, completely exhausted.

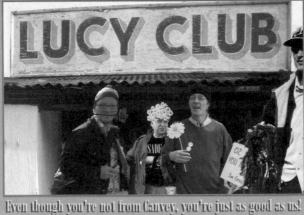

Even though you're not from Canvey, you're just as good as us!

ART U NEED NEEDS U
This is An Outdoor Revolution

Saturday 31 March
IT'S A WRAP!
Warren Studio, Towngate Theatre, Basildon 7-10pm

...s to celebrate the end of **ART U NEED NEEDS U**. ...ll be your last chance to have a go at ...KERS' CORNER, from **7pm**. Go on, have a go! ...provided. At **7.30pm** Town Crier **Jim Shrubb** will ...ace the commencement of the **DIARY WINNERS'** ...ying. Bumper Goody Bags will be awarded by the ...man of Basildon Council, **Sandra Hiller**. At **8pm** ...ll be treated to the **POETRY SLAM! HIGHLIGHTS** ...et **Fiona Curran** on the megaphone. Young poets ...l + **TRUSAY** will lead the way, followed by **Lisa** ..., **Greg Horner** – our Slam! Champ – and **Rosie**, ... **Amy Hassall**. Sadly Neil Horner can't be with us

to tell us why he's Sports Mad! At **8.30pm** or thereabouts I invite **U** to eat **CAKE!!** whilst I hand out the **Souvenir Goody Bags**. Then from **9pm – 10pm** it's **MUSIC MAYHEM** with local bands **DEFERRED SUCCESS**, a four-piece from Essex who play edgy, raw, power-folk with a view to blowing the cobwebs out of the UK acoustic/folk scene **THE LOCAL WILDLIFE** who play "fresh little fugues of busked out rhythms and busked out lyrics" + **BOOTSALE** who cite their influences as Pitsea Market, Ian Dury and the Blockheads, Ian down Pitsea market, Sonny Jim, Derek and Clive + Eddie Izzard. PLUS! **DJ RICHIE DON** IS ON THE DECKS! **COME ON DOWN.** ANDREA MASON ©2007

commissions | EEDA | Thames Gateway South Essex | ART U NEED *An Outdoor Revolution*

...ORE DETAILS, EMAIL **info@artuneedneedsu.org** OR CHECK OUT **artuneedneedsu.org**

The vintage, open-topped bus from Canvey Island Motor Museum tours the island.

A tribute postcard to Lucy made by the members of the concretebarge.co.uk website.

Andrea Mason's "Wrap Party" cake.

SUNDAY 1 APRIL 2007

April Fools Day.

Milika Muritu's *Queensway Streams* launch party.

London's art world squeezes into two stretch 4x4 limos to belt down to Southend to witness the lights being turned on at the Queensway Estate. The party is in full tilt when we arrive, and although it is bloody cold, it is bright and sunny and there are masses of residents and passers-by all drinking pink Cava and wearing some very bling Perspex key-chains Mili has had made for everyone.

The glamorous, but essentially abstract nature of Muritu's work seems to hold everyone together. Southenders and Londoners have a great time whizzing up to the 15th floor, where a viewing point has been established to see Southend glow in either shatteringly toxic orange or green.

In the back of Mili's limo whizzing back to London like Keith Waterhouse's *Billy Liar*, I write a speech in my head about what could be....

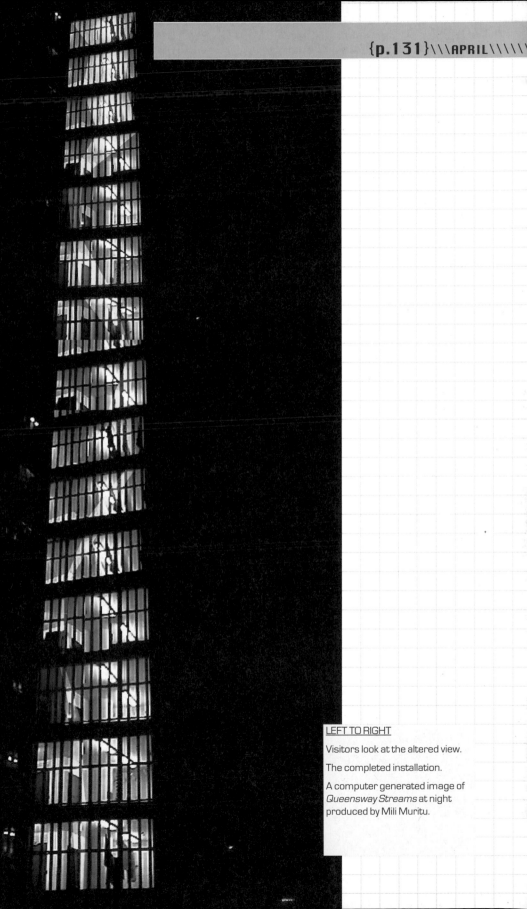

LEFT TO RIGHT

Visitors look at the altered view.

The completed installation.

A computer generated image of
Queensway Streams at night
produced by Mili Muritu.

The keychains handed out by Mili Muritu to hold the newly reclaimed keys to the laundry rooms.

In Jane Wilbraham's cook book there is an advert for "Wilbraham's Tonic to Cure all Social Ills". Has her tonic worked? I am not sure. But what I am sure of, is that *Art U Need* has provided an antidote to the kind of large-scale public art that tells people to rally around an iconic image. Artists who promote what they call their own 'excellence', and 'dog-whistle' to the popular imagination to come and worship, are lazy and self-regarding. What we have done has been to uncover the reality of the existing communities in South Essex.

Public bodies involved in regeneration may find our art embarrassing. TGSEP has contributed to community engagement and a quality of life which puts culture at the heart of regeneration in South Essex. What we have found is obvious and for all to see, that is, the communities of South Essex and The Thames Gateway already exist and have a culture. These communities have histories and desires for the future that must be met by politicians. The Thames Estuary is London's backyard, rather than its gateway. In a backyard you prepare, have provisions, you work and you play. For years, east London and the Estuary has had to deal with more affluent London's exported problems. During the 1980s, Shirley Porter expatriated Westminster's unwanted poorer citizens to Barking and Dagenham and beyond. A pessimist would be suspicious of the densely packed, ungenerous housing that is already being built. It is the low-paid service workers of London who will have to live in this cheap housing. What awaits the existing networks, the communities and the wildlife?

ART CURE

MOST EFFICACIOUS TREATMENT
FOR ALL ILLS

PATENTED 24 MARCH 2007

In my speech at the launch of *Art U Need*, I speculated that what was needed was not house building but the creation of Britain's first 'Urban National Park'. Create desire by limiting housing. The RSPB's nature reserve at Purfleet provides the key to the right kind of regeneration project. It is high quality and popularist. It is for the specialist, but by virtue of its educational role, for everyone. The Rockefellers bought the New Jersey coastline that is viewed from north Manhattan, because they knew life in New York would be unbearable without the sanctuary provided by New Jersey's southern-most forest. Life in London is fast becoming unbearable and the development of a 'National Urban Park' to London's east would do far more to regenerate London than an illusory sporting event in Stratford. Hey politicians, why not do both?!

Mili's project launch in Southend is the last formal event for *Art U Need*. We hope the walks and talks and events continue and grow but the central principle that art is made for and by people and that artists are only one part of the equation has been well made and continues. *Art U Need* has been a conversation about who we are and who we want to be.

or at least ?

Jane Wilbraham's "Art Cure" for the treatment of all social ills.

An alternative way of looking at public art. Bob and Roberta Smith, 2007.

THE RENDEZVOUS CLUB, CANVEY HEIGHTS, CANVEY ISLAND \\\\\\\\\\\\\\\\\\\\\\\\\\\\\\\\\

In the early decades of the twentieth century, Canvey Island was a popular tourist destination for Londoners looking to escape the city. In 1953, a devastating flood destroyed much of the Island. In its aftermath Canvey was extensively redeveloped and many new houses were built. 50 years on and the population is still divided. The 'old Islanders' are proud of how many generations of their family have lived on the Island, remembering life before the flood, and nostalgic for the days when the Island was "all fields". They don't often mix with the 'new arrivals'. People would say to me "I don't know anything about Canvey, you should ask my parents", or "I'm not a real Islander, I've only lived here for 30 years." I found that the social scene of Canvey Island is something like a club. It's difficult to gain access, but once you're in, you're in.

The location of my project was Canvey Heights Country Park, which is built on top of a concrete capped landfill site, and which people still call "the tip". I talked to a local councillor who told me that if there were ever another flood, Canvey Heights would be the last safe place left on the Island.

After some thought about what to do with this strange and compelling location, I decided to start a walking club, as an attempt to do something quite modest—to get people to meet and talk to each other and to make use of the remaining public spaces in the area. I copied the design of the membership card of a local social club, and named my project The Rendezvous Club, after another club, which burnt down in the 1930s. The idea was to rethink the psychogeography of the area by making maps and suggesting themes that related to Canvey: 'Nostalgia', 'Private Property', 'Rumour'. I decided I would photograph people who had met that day and record what they had talked about.

I began by contacting people who could help me with my project. I phoned the list of numbers given to me by my steering group. Then put a load of posters up around the Island. I tracked down local websites and e-mailed people asking to meet. What I was trying to find was an alternative history of the place. I wanted to concentrate on fragments and anecdotes that would not usually be found in history books, but somehow provide an insight into the way a place finds its identity.

Many of the people I had made contact with offered to pick me up and take me for walks across the Island. During the summer I spent several days tramping through fields with complete strangers. They took me to social clubs and cafes, along the sea wall or to their houses, and gave me old guidebooks, maps and photographs. After a bit of initial suspicion, they seemed to take me in as if I had known them for years—although even after many weeks a lot of them still seemed to think I was 21 and doing a college project. In their own way, the people of Canvey had become my tour guides.

I believe there is a generic understanding of local history that bears no real connection to a place's population. The people confirmed this to me by pointing out bits of concrete, bungalows, and scruffy car parks where nightclubs used to stand—small things that are never taught in history classes. I gathered these places together into a book, appropriating the name of an old guidebook, *Captivating Canvey*. A local sign writer called "Bob the Brush" designed a beautiful cover, inspired by the graphics of the original publication. I also made an audio guide, recorded to sound like a museum guide, which detailed cherished places and moments that had been pointed out by my new Canvey friends, for instance a place where someone once got left out in the rain, or where an interesting piece of graffiti used to be.

On the launch day, all the contributors were invited to take people on guided tours. I brought a coach full of people down from London, to act as tourists for the day. I'd asked Bob the Brush to make signs for each location and imagined them being left in the ground at each spot, but the people liked them so much that they carried them around like placards. Quite a few people asked us what we were protesting about. One of the stars of the day was a retired bouncer who took control of one of the groups and told them all about his glory days as a boxer.

The party in the evening was in the Canvey Club, which is like a shed with West Ham flags hanging up

Lucy Harrison (second from right) with Canvey Islanders at the meeting point of The Rendezvous Club.

on the wall and an outside toilet for the men. There are two strange window boxes that look like shrines, complete with plastic flowers. Someone told me that they contain the ashes of the club owner's parents. All the residents were very positive about the project. They gave me a copy of the guidebook signed by all the participants, and one of them got up and gave a speech saying how proud they all were to "have been chosen" for the project. Many of the residents told me that they had met people they hadn't seen for years—despite being neighbours.

After the project, I had a plaque made marking out the meeting place of The Rendezvous Club, in the hope that it would continue without me. The first walk organised by the residents went on the route of the old carnival, and they handed out paper hats and leaflets advertising the next one. They've drawn up a rota, and thought of the routes they want to go on. Some of the people who were involved are now putting together a 'Community Archive' website. I made a residents' pack to be given out by estate agents to people moving to Canvey Island. It includes an invitation to the monthly walking club and a copy of *Captivating Canvey*. I hope that these will provide a way for people to introduce themselves to each other in the future.

I was worried that this project could be seen as just another bit of the nostalgia business, but the ambition of the project is to go much further than that, and to explain why and how people relate to and take pride in the place that they live.

2

4

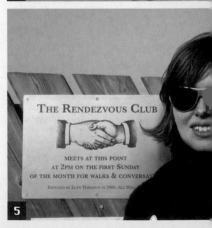

5

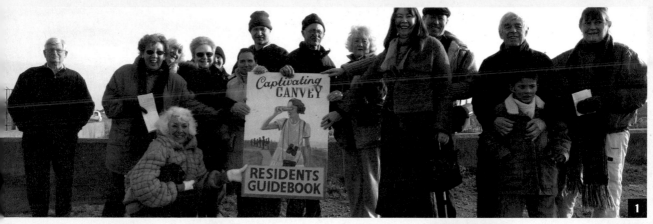

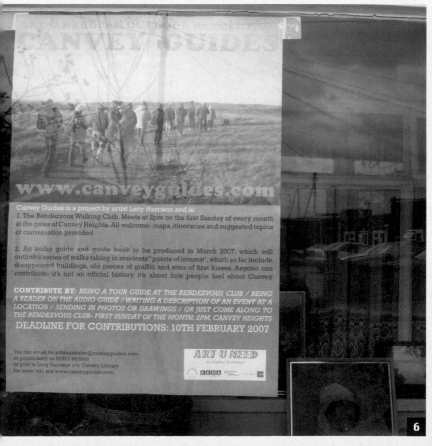

1. Residents of Canvey Island pose with Bob the Brush's sign for the *Captivating Canvey* guidebook.

2. The Rendezvous Club at the Sailing Club at Canvey Island.

3. The launch party at Canvey Club.

4. The open-topped vintage bus from the motor museum that took Islanders and Londoners around Canvey.

5. Lucy Harrison stands by a sign advertising the ongoing meetings of The Rendezvous Club.

6. One of the posters Lucy hung around the island, trying to get people involved with her project.

ART U NEED NEEDS U, NORTHLANDS PARK NEIGHBOURHOOD, BASILDON \\\\\\\\\\\\\\\\

My part in the Art U Need Outdoor Revolution took place in Northlands Park Neighbourhood, a low-rise, "1970s add-on" to New Town Basildon. It has a population of about 10,000 people, mostly council tenants. With no local pub, no greasy spoon cafe, no launderette, no focal point at the heart of the neighbourhood where people can gather and chat, I felt an absence of a sense of community. In conversations with people it became apparent that a culture of fear pervades—people are afraid to take their children to the park because of paedophiles (there is a remand centre nearby), they're scared of walking around the neighbourhood, or in the woods, and they're wary of getting involved in activities because "some of the people in this neighbourhood are not very nice".

I was shown around the estate initially by a group of residents who pointed out a number of underused, neglected and/or misused sites, that immediately lent themselves (in my mind) to specific activities: a green space opposite Plumleys with a Teenage Village sited in the middle became "Speaker's Corner"; a street corner notorious for drug dealing and using, became "Poet's Corner"; Nevendon Bushes, a 15 acre site of very pretty woodland, was an obvious venue for a "Wildlife Walk" and a "Ghost Walk" and a small green opposite an old people's home became "Painter's Green". The central car park at the heart of the neighbourhood, servicing a collection of shops including a cash point which charges £1.75 to withdraw cash, was designated "Nowhere". Nowhere being another word for Utopia and also a starting point for the re-mapping "Mis-Guided Walk", in which artists' collective Wrights and Sites each led off a group in the directions of north, south, east and west.

With these sites as my 'stage' and the Northlands Park residents (hopefully) as my 'players', I programmed a series of outdoor events and activities to take place from January to March. The events in January were mainly walks; in February, mainly performance events; and in March mass events. The first Saturday of the month was

"Speaker's Corner", the last Friday of every month was a "Ghost Walk", and the first Monday of every month was a "Designated Day", which mirrored the National Day/Week campaigns to effect a healthier, more environmentally aware lifestyle (walk to school day, walk to work day and car-free day).

My project, Art U Need Needs U, was a campaign—the active word being "U"—a direct call to arms to the local population to get outdoors and to get involved.

The events were as simple as they could be to participate in, requiring only that an individual turn up and speak, walk, draw, re-map, Slam! some poetry, listen, jump, throw a frisbee, hug a tree, find some art and/or eat a picnic. The regularity/repetition of these events was intended to imprint the activities onto the residents' collective psyche in the hope that they might continue the activities after the end of the project.

To document this programme of activities, I produced a diary publication, which I handed out to residents at the Northlands Park Neighbourhood Christmas Fayre. The diary listed all the events and designated days, and also included suggested activities—jumpers-for-goalposts footie, follow the leader, look at the cracks in the pavement, piggy-in-the-middle—mostly traditional children's games and activities now in danger of being lost to technology. As well as being a programme of events and instruction manual, the diary was an interactive tool, encouraging people to draw/rant/write in the spaces provided. There was a competition for the ten best diaries at the end of the project.

The diary was backed up by a website (www.artuneed-needsu.org) and a blog (thebasildonblog.blogspot.com). The blog was a "behind the scenes" working notebook, which was intended for residents to read and find out what was happening and get involved by posting comments and stories. I also set up a MySpace site which proved to be a vital tool. Although I didn't have much luck contacting Northlands Park residents, I did manage to get in touch with numerous residents from the neighbouring town of Pitsea. In this way I met local bands Deferred Success, The Local Wildlife and Bootsale, who all played at "Guerrilla Gigs" and various events throughout the project, as well as

A member of the Northlands Park
steering group, Vin Hallop, shows
the love, in Andrea Mason's "Mass
Tree Hug", 11 March 2007.

Swift-Freedom, the local parkour posse who ran the "Parkour Workshops". I also discovered DJ Richie Don of MTV's *Pimp My Ride* fame, a DJ and a dog-lover who both hosted the "Dog-Off" and DJed at the "Wrap Party".

At the "Wrap Party", hosted at the end of the project, I handed out a really great Souvenir Goody Bag jam packed with memorabilia of the *Art U Need Needs U* events, and a special bumper goody bag for the winners of the Diary Competition.

My overall feeling is that the project was a success. Between ten and 20 people turned up to most events, and 40 to the "Dog-Off!". The "Parkour Workshop" was popular with local kids and Swift-Freedom hope to do more workshops in the area. The "Street-Corner Poetry Slam!", aimed at 12 to 18 year olds inspired some really heartfelt poems. Deferred Success enjoyed the "Guerrilla Gig" and plan to do it again incorporating more bands. "Speaker's Corner" built as the months went on, with the locals becoming increasingly vociferous. A local contingent recently visited Speaker's Corner at Hyde Park for more inspiration. Local artist Lisa Horner, who attended almost every event, plans to take on the legacy of *Art U Need Needs U* with her own version of the activities (www.artcafeinc.blogspot.co.uk).

It was not an easy population to communicate with and there was zero uptake from any organised groups/institutions despite my approaches. Though I must say I liked it that way, preferring individuals to take the initiative to come to events rather than being fielded in. One headmistress vetoed the Diary because of the use of language in the tagline that Bob and Roberta Smith had devised; "Don't let the bastards grind you down." There was little response to the Diary Competition (two entries) or the blog. It rained a lot, the fields were boggy, I sacrificed my best boots to the project, but a lot of fun was had, I met some new friends and I learned a lot from it. I hope that *Art U Need Needs U* has created a blueprint of activities that can become part of a new reality for Northlands Park. A shroud or shadow... a parallel reality for the Neighbourhood, hovering in an air of possibilities....

2

4

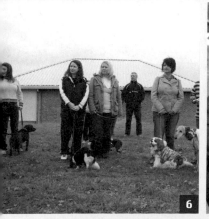

6

7

1. A resident speaks out at one of the "Speaker's Corner" events.

2. More participants in the "Mass Tree Hug".

3. Teenagers get engaged at the "Poetry Slam".

4. A view of the more pastoral area surrounding Northlands Park Neighbourhood.

5. Swift Freedom's "Parkour Workshops".

6. "It's A Dog-Off!"

7. Local band, Deferred Success play at "Guerrilla Gigs".

QUEENSWAY STREAMS, QUEENSWAY ESTATE, SOUTHEND \\\

Southend-on-Sea is renowned for the cheap glitz and glamour of its pleasure beach. It is famous for having the longest pier in the world, which for over the last five decades has continuously burnt down and then been resurrected and reinvented. In 1967, *The Evening Echo* ran a competition for ideas to redesign the pier and restore some of its former glory. One idea was to nod to the pier's combustible past by creating illuminations on it to give the impression that it was permanently on fire. This aspiration of spectacle and rejuvenation became a starting point for the project.

The Queensway Estate is a sprawling area of concrete and green space on the outskirts of Southend, with the A13, a main arterial road, running straight through the middle of its four 15-storey tower blocks. From the top floor you can see the incredible views of The Thames Estuary to the south and the Hockley Hills and its suburbs to the north. From the ground it's less attractive. It backs onto the main commercial area of Southend, which houses a large shopping centre and one of Britain's main Inland Revenue centres. My first impressions of the estate were that it seemed unnoticed and dislocated from the rest of the town centre.

The residents on the Estate are a diverse group. There is a tiny minority who have been housed there since it was first built. They remember when Queensway was a part of the shiny modern vision of Britain in the post-war era. They tell tales of collecting keys from Southend's Civic Centre as part of a grand ceremony. The stories told of life in Queensway today, however, are very different. The Estate, like many of its kind, is used to house difficult residents or people on the housing list. The fear of drug related crime and violence has replaced the original community spirit and the majority lock themselves in their flats without any contact with their neighbours.

My first meeting was with Mike Chapman, one of Queensway's residents who feels passionately about his Estate, and wants to improve its image. We discussed the situation and concluded that the residents needed more to be proud of; there needed to be a talking point, so that people would leave their flats and start chatting to each other. We targeted the laundry drying rooms and outdoor space as a location for the project. These rooms were communal areas, available to all seven flats on every floor. Each floor had a key, similar to a garden or a communal shed.

Once I had chosen the location of the projects, I drew up a questionnaire and, with Mike Chapman's help, paid a visit to as many of the residents as possible. Seven days and 830 people later, I had the results, and they were intriguing. Whilst a few of the rooms were used by elderly residents to hang out washing, many were left empty, with residents unaware that the space was even available to them. Those who used the rooms had a sense of trust and negotiation between each other as neighbours, but the younger residents, who were unaware of the facility, were much more wary of one another.

The buildings on The Queensway Estate are named after hills in the British countryside—Quantock, Chiltern, Pennine and Malvern—reflecting the initial optimism of the 1960s. The idea behind *Queensway Streams* was to resurrect some of that optimism, by uniting the architecture and offering a unique talking point for the residents of the Estate. I wanted to make each laundry room unique and still keep its ultimate function, and I wanted residents to be aware of an intervention inside the room, which would be visible from the outside, not just for them but also for the community as a whole. Using coloured acrylic, I decided to recreate the illuminated effect so characteristic of Southend-on-Sea.

My original design required an angle bar, or brackets installed into the reinforced concrete of the building, to hold the acrylic in place. This would have demanded lengthy drilling using heavy-duty power tools, which, I was informed by local contractor, Glorcroft, would entail very high noise levels, not to mention labour costs, if it were to be carried out on all floors. Mike Chapman happened to be an engineer, on top of everything else, and after lengthy discussions over lunch and a pint at The Cork and Cheese, he devised a plan to suspend the Perspex acrylic sheets from the

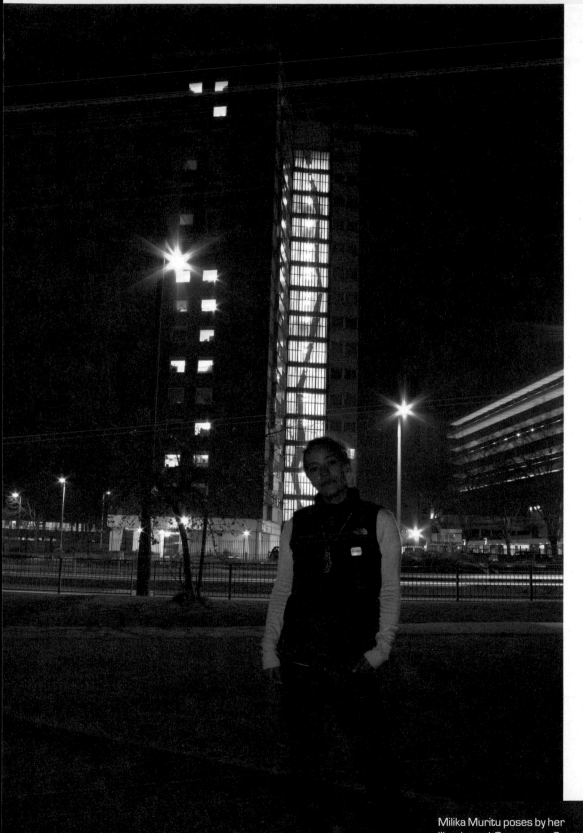

Milika Muritu poses by her illuminated *Queensway Streams* installation.

existing grills in the building using threaded hex bars, washers and bolts. This was an elegant solution to the problem, making the work an integral part of the architecture, utilising low impact installation using Allen keys and cordless drills.

With the concept and the basic execution tied down, the work went into production by Southend's AllJay Plastics (John Goodge and Paul Hartley).

On 1 April, the *Streams* were launched with celebratory champagne and canapés on the 15th floor of Quantock. Two limousines were arranged to transport Londoners to Southend and Rossis Ice Cream of Southend made 'Queenscream Sundaes', which were served to all. Many residents had applied for a key to gain access to their own rooms and some saw them for the first time at the launch. A limited edition shiny commemorative key ring for each resident was designed and made from the off-cut acrylic in the same colours and same shapes as the *Streams*. This went down well with the young families and trendy mums. "Bling up da massive!" was the reaction from a few.

Since the launch, Mike has re-launched his residents' newsletter (put to bed two years ago) after talking to people at the party and finding a renewed interest in what was going on around the estate. The *Streams* themselves are still there and have not been vandalised. The key rings are being used and symbolise a new identity for the tower blocks. Now you can see people looking up at the tower blocks, especially at night, and pointing. Or you can access the laundry rooms to find residents looking out at the views through the filter of coloured acrylic. Changing the way the Estate is viewed or perceived—that is The Queensway outdoor revolution!

2

4

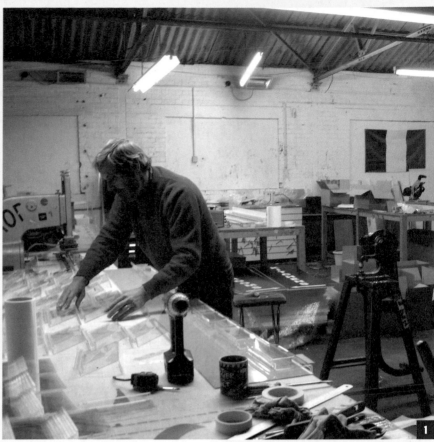

1. The cutting of the Perspex at Southend's AllJay Plastics.

2. Installing the *Streams* using Allen keys and drills.

3. The Queensway Estate by day.

4. The questionnaires handed out to the residents of The Queensway Estate regarding the use of the laundry rooms.

5. A view of Southend through the coloured Perspex.

SECRET SCULPTURE, ROCHFORD RESERVOIR, ROCHFORD \\\

My Art U Need location was Rochford Reservoir in Essex. Rochford Reservoir is a lush and green site next to the railway station in this small market town. The railway came to Rochford in 1889 and the reservoir was built to provide water for steam trains on the London to Southend line. The area is now a public space where people walk their dogs, fish, visit the miniature railway and feed the ducks and geese that live on the island in the middle of the pond.

I became curious about what was in the water, rather than what was around it. I had a dream about divers searching for something that had been lost beneath the surface of the Reservoir. In a strange twist of fortune I was told there was a dive club next door to the council offices in the middle of landlocked Rochford. While researching the project I also came across a piece of local history relating to a white post—known as The Whispering Post. The story of the post dates back to around 1600 when the Lord of the Manor returned home to find his tenants whispering and plotting to murder him, after which he demanded that his tenants meet around the post at midnight on the Wednesday after Michaelmas to pay him homage in a whisper.

Drawing on both my dream and the story about The Whispering Post, which made me think about the unofficial role of rumour and gossip in making something 'public', I proposed a sculpture that would be designed and fabricated in secret before being dissembled, thrown into the Reservoir, retrieved by divers and put back together again by a group of people who did not know the original design.

The process of making Secret Sculpture was contradictory. The making of the sculpture was advertised as a series of public events happening at Rochford Reservoir. The title might also be taken literally—Secret Sculpture—a sculpture that is designed and made in secret before being hidden or stored at the bottom of the reservoir. I decided that I wanted to make a public sculpture that would pass through the public's hands in as many ways as possible—through authorship, employment, rumour

and through the 'staging' of the making of the sculpture in public.

The first part of the project took the form of a workshop in which students from King Edmund's School in Rochford were given the project brief and asked to propose a design for a public sculpture that would be located on the island in the middle of the Reservoir. This committee of teenagers agreed the subject; a series of flying ducks. The sculpture was then designed and built by two local craftspeople—John Parker and Jeff Hatt. Working through Christmas 2006, Jeff designed a self-supporting structure consisting of three interlocking ducks. Constructed from marine-ply, the sculpture was made like a giant puzzle that could be taken apart and put back together again. The sculpture was fabricated at a workshop in nearby Rawreth, where it was photographed before being dissembled and transported to the Reservoir.

At the Reservoir's edge, 1,000 horseshoes were used to weight individual sculpture parts before they were rowed out onto the water and sunk. Driving rain and 100 mile per hour winds gave the drop an epic quality, made more surreal by the presence of a large number of photographers, St John's Ambulance, a diver, boatmen, local residents and invigilators dotted around the Reservoir. I later heard that this spectacle had started a rumour that there had been an accident at the Reservoir that day.

A week later, members of the Rochford based scuba-diving club, Dive Odyssea, retrieved 32 of the 36 sculpture pieces. Six divers and a rower braved the frozen waters of Rochford Reservoir, spending one and a half hours looking for the sculpture parts. At its deepest point the Reservoir is only four meters deep and the experience of the dive was somewhat underwhelming for club members used to deeper and clearer waters. Once retrieved, the sculpture parts were displayed overnight at the edge of the reservoir.

Secret Sculpture was finally reassembled using the ancient boat-building technique of roving. The group that put the sculpture together again did not know the original, and were in the process of making an incredibly beautiful sea creature when one of the ambulance men had a eureka moment and recognised

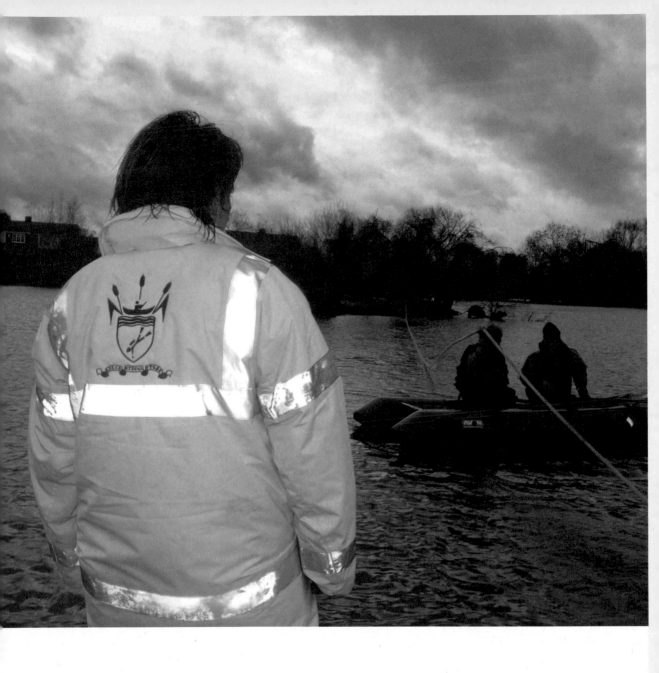

Hayley Newman (with the *Secret Sculpture* logo embroidered on her jacket) watches as the *Secret Sculpture* is dredged up from Rochford Reservoir.

that the sculpture was actually a duck. And so it was that despite three missing pieces, the puzzle of *A Secret Sculpture* was solved. Finally, in a *Swallows and Amazons*-style exercise we built a pontoon and floated the sculpture over to the island in the middle of the Reservoir where it was installed.

A Secret Sculpture is a reflexive public artwork. Its varying stages of design and fabrication try to consider and reveal something about the nature of public art production as well as the role of the artist within the commissioning structure. At the time of writing, the sculpture is still on the island where it will remain undisturbed until the end of the nesting season. A decision has yet to be made as to what will happen to the sculpture, but I like the suggestion made by a local councillor to burn it in the Market Square. A similar fate to one John Simpson, burnt at the stake on or near the market square in 1555.

1

12 Echo Friday Decembe

Can you keep a secret?

ARTIST Hayley Newman is seeking people who can design and keep a secret.

A Secret Sculpture is a public artwork taking shape at Rochford Reservoir and she is looking for volunteers of all ages to help with the design the sculpture.

She said: "It will be designed in secret by one group of Rochford residents and assembled by another group, who will not be privy to the original design.

"Workshops will take place behind closed doors at Rochford library on the evenings of December 7 and 14."

The workshops will include a presentation, insights into Rochford's history and a discussion.

Art U Need is a programme to regenerate neglected open spaces.

To join the workshops, contact Hayley on 07930 532201.

For details see **www.a secretsculpture.org**

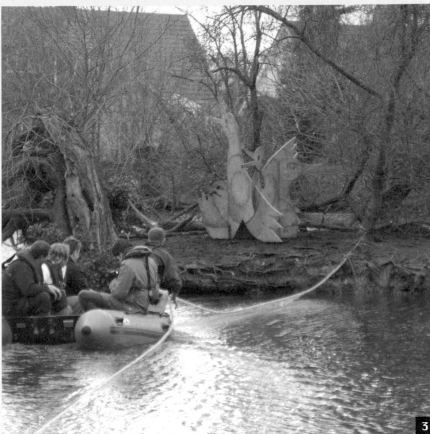

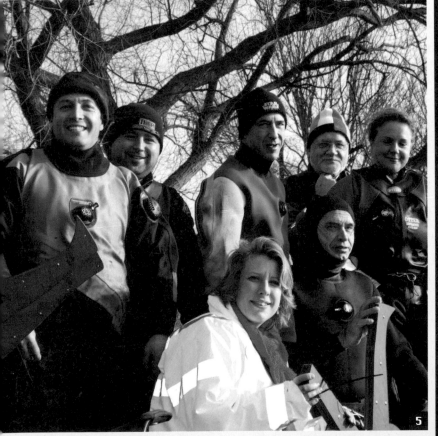

1. Led by Hayley, the youth of Rochford design *A Secret Sculpture*.

2. Horseshoes are attached to the parts of the sculpture before it is submerged in the water.

3. The sculpture is installed on the island.

4. A call for participants in the design of *A Secret Sculpture*, *Basildon Echo*, Friday 8 December 2006.

5. Hayley and the Odyessa Dive Club with the retrieved parts of the sculpture.

THE PURFLEET ONE FLOAT CARNIVAL, OR THE RE-INAUGURATION OF THE MINISTERIAL FISH DINNER, PURFLEET \\\\\\\\\\\\\\\\\\\\

When I first visited Purfleet in the early summer of 2006, what hit me was the strange absence of anything resembling a town centre, high street (it's on the map, but not on the ground), or any sort of social hub. Where did everyone go to do their shopping? What if you just wanted to buy a bunch of bananas, a bag of sugar, a bit of fresh veg? Well, I suppose the Costcutter on the dilapidated parade of shops on The Garrison Estate could provide that if you felt brave enough. Otherwise, it's off to Lakeside, Thurrock.

Purfleet seemed to me like an island, bounded by river, bridge, road and marsh and made up of islets of social activity: the primary school, the heritage centre, the sheltered housing development, the church and on the edge of Purfleet, the sparkling new RSPB Centre. With no links between these various islets, there was a feeling of geographic and demographic disjointed-ness about the place: an interesting environment to create a 'sculptural event' of some sort I began to think....

I decided to approach the first meeting with my local 'steering group' with candid honesty and explain that the apparent lack of infrastructure in the area, specifically relating to food shops, would provide the basis of what I wanted to work on for the commission. Some people seemed dubious, and one local councillor declared: "I don't see what that's got to do with Purfleet... what's food got to do with Purfleet?" But others were more positive, agreeing that the lack of local shops was indeed a real pain; why couldn't they have a farmers' market or something similar? The elderly people from the sheltered housing had a self-imposed curfew during the evenings from a real or perceived fear of the estate and its inhabitants and had to rely on the very infrequent bus service to Thurrock or relatives for their shopping, and the proposed new Purfleet town centre seemed to be a thing of myth. Someone else offered that Purfleet had been a popular day-trip destination during the Edwardian era, where diners would enjoy whitebait dinners at the fashionable Royal Hotel on the riverfront. This was a totally unimaginable proposition now. I was intrigued, and decided to research this further.

The Ministerial Whitebait dinners originated in a location close to Purfleet in the mid-1700s. Initially an informal gathering between senior Ministers of the Crown, which was later extended to the prime minister and all parliamentary gentlefolk, these dinners were most probably a great opportunity for a riotous party well away from the prying eyes of the city. Purfleet was the ideal 'out of sight, out of mind' location for a party. This seemed to have a contemporary resonance in the way that inhabitants of Greater London seemed to be unaware of the political manoeuvring that was taking place in order to make The Thames Gateway the single biggest housing development in Europe, and the impact that had on the local population.

Taking the Ministerial Whitebait Dinner as a starting point, I paid a visit to the Purfleet Heritage Centre, housed in a magnificent eighteenth century gunpowder magazine. It contains an extensive and slightly bizarre collection of all things military and Purfleet-related. Wandering around this old powder keg, amongst the canons, rifles, prisoner-of-war ephemera and bits of old planes, I thought to myself: "The eighteenth century ministers may have enjoyed their little whitebait, but what about a bloody great big 'Trojan fish' returning to survey the state of twenty-first century Purfleet?"

I decided to establish base camp at the primary school, setting the pupils to work making fish and fly helmets for them to wear when 'guarding' the giant fish. I sent word to the Purfleet community at large that their contributions were required for the *Purfleet Cook Book* which would be a subversive piece of propaganda, consisting of recipes, food memories, anecdotes, etc., which we would 'drop' on the inhabitants from the fish on the launch day. The making of the *Purfleet One Float Carnival or the Re-inauguration of the Ministerial Fish Dinner* was now well underway.

Weeks seemed to fly by in a haze of frantic activity as the fish was built, the cook book was edited, designed and printed, fliers were distributed and fish and fly helmets were made. A seven ton truck was requisitioned to transport the fish on its short tour, and vintage fairground band organ music was found to accompany the spectacle. The launch day arrived soon enough; we gathered at the school—a few brave souls wrapped up

Kids peer into the belly of the gigantic fish at the *Purfleet One Float Carnival*.

against the freezing Estuary wind. As we drew back the curtains on the sides of the hire truck, a ripple of astonishment went through the modest crowd, or it might have been a collective shiver as the early stages of hypothermia set in. The procession set off, with "Let Me Call You Sweetheart" blaring from the speakers. The inhabitants of The Garrison Estate were just rising, and at 11 AM on a Saturday this was not their usual alarm call. Bemused spectators peered nervously from windows and as we drew up on the small car park next to the Costcutter a few more people had joined the small crowd, eager to have a closer look at the fish. As people ascended the staircase onto the truck, the sense of something unexpectedly positive happening was palpable.

The day was a success; we distributed cook books, gave the children far too many small chocolate fish and delighted those who braved the weather with a spectacle that I can safely say is not a common sight in Purfleet, but did we fulfil any of the grand socially regenerative objectives in the commission brief? It's hard to tell, and for what it's worth, I understand more fully that it's impossible to create something with those objectives in mind unless you happen to be an artist who is also a social worker, politician, psychiatrist, health worker, town planner and behavioural psychologist.

Since the end of the project, the last few copies of *The Purfleet Cook Book* have been changing hands between local residents for cash (a re-print is in the pipeline along with preparations to publish volume two). There are plans to dust the fish off and give it another outing at the inaugural Purfleet Festival (an event that will, it is hoped, combine a small fair or carnival with a fresh foods market), and the school has now made a connection with the Heritage Centre which has made a connection with the church. Strangely, *The Purfleet One Float Carnival or the Re-inauguration of the Ministerial Fish Dinner* has already begun to take on something like minor cult status in Purfleet. I now like to think of it, in my more self-regarding moments, as a bit like one of those early Sex Pistols gigs that everyone says they were at, but actually only about ten people were there, and those ten people all went on to do something really great.

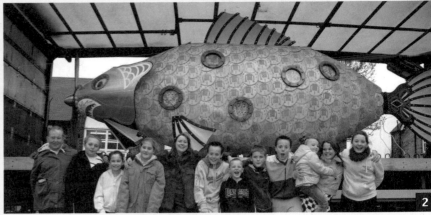

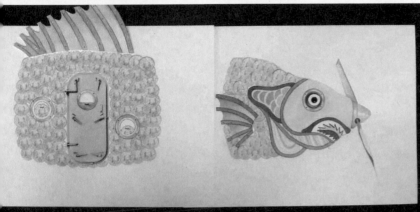

1. The construction of the fish's frame.

2. Excited children pose in front of the float.

3. A technical drawing outlining the three parts of the fish, destined for the three different venues in Purfleet.

4. The whitebait helmets worn by the kids of Purfleet.

5, 6. Workshops at the local school, in which Jane helps the children design their costumes to guard the fish.

\\\\ACKNOWLEDGEMENTS\\\\\\\\\\\\\\\\

Commissions East would like to thank the following people for their support in realising Art U Need: Nicky Adamson, Dave Addy, Hayley Allen, Tim Balogun, Jane Bhoyroo, Simon Black, Janine Blinko, Alan Cass, Mike Chapman, Kate Clayton, Caroline Coates, Geoff and Shirley Coates, Nicola Dean, Ben Dodd, Claire Downs, Lesley Farrell, Gaynor Fisher, Tessa Frampton, Anne Kathrin Greiner, Tony Guyon, Tracey Hannington, Mike Harrington, Susan Harper, Joerg Hartmannsgruber, Sophie Hope, Lisa Jefferys, Demus Lee, Gary Lilley, Martin Little, Mary McHugh, Paul Macklin, Emily Malcolm, Des Merry, Fraser Muggeridge, Paul Nagle, Rosemary Pennington, Jayne Reader, Mark Richards, James Roberts, Catherine Sackey, Fiona Scerri-Headley, Sarah Tanburn, Maureen Vince, Cheryl Williams, Simon Williams, Debbie Woods, and all the members of the steering groups in Basildon, Castle Point, Rochford, Southend and Thurrock, C2C, English Heritage and Lucy Bradley.

Thanks also to all the five artists, who were so generous with their time and efforts in helping put this book together.

Bob and Roberta Smith is represented by Hales Gallery.

ART U NEED

An Outdoor Revolution

\\\\\PICTURE CREDITS\\\

ANNE KATHERINE GREINER	8 and 9, 16, 18, 23, 24, 26, 27 (B), 34 and 35, 44 and 45, 68 and 69 (C), 74, 76, 84 and 85 (all), 92 (T), 95, 103, 110, 111, 118 and 119, 122 and 123 (all), 126 and 127 (all), 130, 139, 142, 147, 151, 152 and 153 (all), 155
BOB AND ROBERTA SMITH	14 and 15, 17, 19, 20, 22 (T and B), 25, 27 (T), 30 and 31, 36, 42 and 43, 52 and 53, 57 (B), 58 (T), 61 (R), 66 (L and R), 67 (all), 70 (C), 88, 89, 94, 106 and 107
VICTOR MOUNT	33
ANDREA MUENDELEIN	41, 54, 55, 64 and 65
LUCY HARRISON	50, 70 (B), 78 and 79 (all), 100, 112 and 113, 120, 121, 128 (T), 140 and 141 (all)
ANDREA MASON	58 (B), 59, 81, 82, 86 and 87 (all), 92 (B), 93, 98, 99, 104, 105, 112, 128 (R) and 129, 144 and 145 (all)
MILIKA MURITU	60 and 61 (L), 77, 131, 148 and 149 (all)
DANIELLE HORN	68 (BL)
MATT'S GALLERY	91
KEITH SARGENT (from the design of Bob and Roberta Smith)	96 and 97
HAYLEY NEWMAN	102
JESSICA VOORSANGER	108 and 109 (all), 116 and 117
BARBARA LAWS	124 and 125
JANE WILBRAHAM	156 and 157
COVER IMAGE	*Art U Need*, Signwriter's enamel on wood. Bob and Roberta Smith, 2007.

© 2007 **BLACK DOG PUBLISHING** limited, the artists and authors

Unit 4.4 Tea Building

56 Shoreditch High Street

London E1 6JJ

T. +44 (0)20 7613 1922

F. +44 (0)20 7613 1944

E. info@blackdogonline.com

W. www.blackdogonline.com

Designed by Rachel Pfleger @ bdp

Edited by Cigalle Hanaor @ bdp

Written by Bob and Roberta Smith

Additional text by David Wright, Lucy Harrison, Andrea Mason, Milika Muritu,

Hayley Newman and Jane Wilbraham

All opinions expressed within this publication are those of the author and not
necessarily of the publisher; East of England Development Agency; Arts Council
England, East; Thames Gateway South Essex Partnership and participating partners.

British Library Cataloguing-in-Publication Data.

A CIP record for this book is available from the British Library.

ISBN 978 1 906155 16 2

BLACK DOG PUBLISHING is an environmentally responsible company.

Art U Need is printed on Cyclus Print, a paper from 100% recycled de-inked post
consumer waste.

architecture art design
fashion history photography
theory and things

black dog
publishing

www.blackdogonline.com

TUESDAY 5 SEPTEMBER 2006

I am live on-air with a journalist. He says, *"Art U Need?* How much is it costing?" I tell him it's going to cost at least the price of two kidney machines. He says "Wouldn't the money be better spent on a kidney machine?" I tell him in the past kidney machines used to be really interesting looking, with all sorts of pipes and taps, but these days they are just a big white box that bleeps. Anyway, they would still get ruined if you left them out on a roundabout....

In March 2005, International artist, Bob and Roberta Smith, was commissioned to act as curator on a series of five public art projects in the "Thames Gateway" area of Essex.

Written in diary form, *Art U Need* charts the movement of public art away from the construction of grand objects to carefully conceived projects that bear relevance to the communities and locales that they are aimed at. Working closely with artists **Lucy Harrison, Andrea Mason, Milika Muritu, Hayley Newman** and **Jane Wilbraham**, as they tackle issues surrounding the roles of funding bodies, self-expression and, of course, the public in public art today, Bob and Roberta Smith provides a uniquely intimate and honest account of the working life of a contemporary artist.

Art U Need; My Part in the Public Art Revolution is a refreshing addition to the public art debate, telling the story of how Bob and Roberta Smith set about changing the world—or at least a bit of it.

ISBN 978 1 906155 16 2
UK £19.95_US $29.95

92995>

9 781906 155162

reuse · recycle · reduce

architecture art design
fashion history photography
theory and things

black dog publishing ■ ■ ■

www.blackdogonline.com